Arts & Crafts
Masterpieces of Art

Publisher and Creative Director: Nick Wells
Project Editor: Polly Prior
Picture Research: Polly Prior and Gillian Whitaker
Art Director: Mike Spender
Copy Editor: Ramona Lamport
Proofreader: Amanda Crook
Indexer: Eileen Cox

Special thanks to: Laura Bulbeck and Josie Mitchell

FLAME TREE PUBLISHING
Crabtree Hall, Crabtree Lane
Fulham, London SW6 6TY
United Kingdom

www.flametreepublishing.com

First published 2015

15 17 19 18 16
1 3 5 7 9 10 8 6 4 2

© 2015 Flame Tree Publishing Ltd

A New Aesthetic images: Courtesy of **Bridgeman Images** and the following: **Cheltenham Art Gallery**: Archibald Knox, Belt buckle, 1903: 6, 128; William Benson, Candleholder *c.* 1900: 13; Ernest Gimson, Chair, *c.* 1895 and Cabinet, 1902: 16, 17; Charles Ashbee, Brooch, *c.* 1900: 19; C. Voysey, Chair, 1898 and Cabinet, 1899: 21, 22; **William Morris Gallery**: A. Mackmurdo, Writing desk, *c.* 1886: 6; **Victoria & Albert Museum**: Wallpaper by S. Scott: 7; William Morris, Chair, *c.* 1870: 8; Charles Ashbee, Salt cellar, 1899: 19; Kelmscott Manor: Photo of Morris' bedroom: 9; **The Hunterian Museum**: Edward Godwin, Butterfly cabinet, 1877: 10; **Private Collection** and **The Fine Art Society**: Philip Webb, Settle, 1865: 11; A. Mackmurdo, Suite, *c.* 1886; Edward Godwin, Designs, *c.* 1860: 15; Koloman Moser, Enchanted Princesses cabinet, *c.* 1900: 23; Josef Hoffman, Concordia Ball programme, 1909: 26; **Leighton House Museum**: Walter Crane and William de Morgan, Arab Hall, *c.* 1870: 12; **The De Morgan Centre**: Charles Passenger, Charger with peacocks, 1888: 13; **Whitworth Art Gallery**: Walter Crane, Wallpaper design, 1899: 18; Peter Kinnear: William Moorcroft, Florian vase, *c.* 1903: 20; **Minneapolis Institute of Arts**: Josef Hoffman, Table, 1904: 24; **Saint Louis Art Museum**: Peter Behrens, Dining chair, 1902: 25; **Hamburger Kunsthalle**: Peter Behrens, Desk, 1908: 26; **Museum of Fine Arts**, Boston: George Maher, Rocking chair, *c.* 1912: 27.

Other images: **Leighton House Museum**: 1, 54, 58; **De Agostini Picture Library**: 3, 67; **Whitworth Art Gallery**: 34, 51, 86; **Calmann and King**, London: 36, 53, 101; **Art Gallery of South Australia**: 38, 39; **Middlesex University**: 41; **Museum of Fine Arts**, Boston: 46, 91; **Royal Institute of British Architects**: 49; **The De Morgan Centre**: 60, 62, 64, 66, 69, 70; **Fitzwilliam Museum**: 61, 63, 68, 73; **Delaware Art Museum**: 71, 72, 85; **Stained Glass Museum**, Ely: 76; **William Morris Gallery**: 81; **Cheltenham Art Gallery**: 90; **De Agostini Picture Library**: 93; **Glasgow University Art Gallery**: 94; **Birmingham Museums and Art Gallery**: 96; **Scottish National Gallery**: 99; **Dublin City Gallery**: 102; and **Victoria & Albert Museum** and the following: 47, 50, 83, 89, 92, 95, 106; **The Stapleton Collection**: 48, 52, 110; **De Agostini Picture Library**: 80; and **Private Collection** and the following: 4, 28, 30, 33, 35, 42, 77, 78, 87, 104, 109, 113, 114, 116, 118, 119, 120–24; **Graphica Artis**: 31; **The Fine Art Society**: 37, 44, 45, 57, 58, 82, 88; **Christie's Images**: 40, 56, 74, 98, 100; **The Stapleton Collection**: 79, 103, 107, 108, 111, 112, 125.

ISBN: 978-1-78361-319-9

Printed in China

Arts & Crafts
Masterpieces of Art

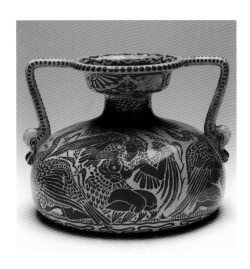

Michael Robinson

FLAME TREE
PUBLISHING

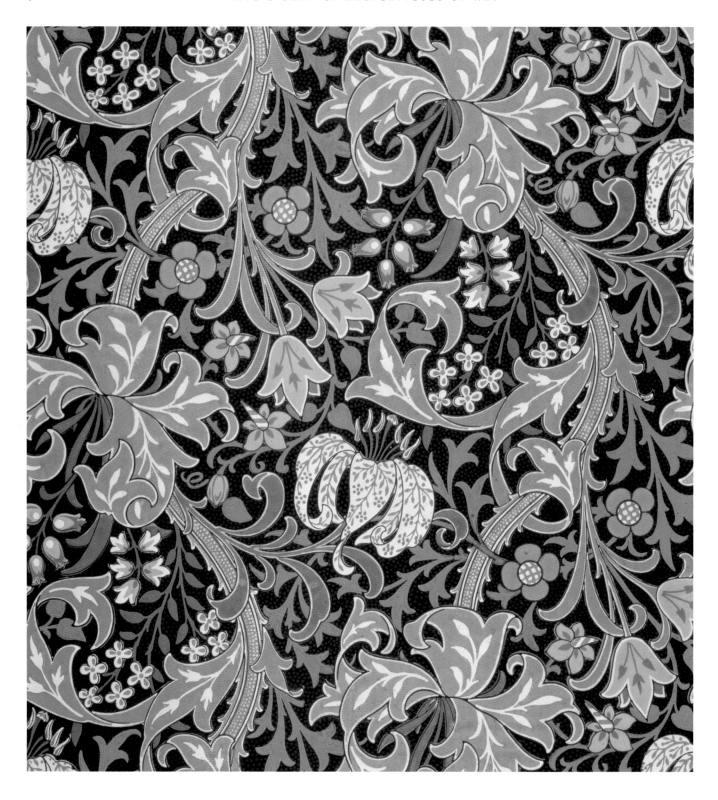

Contents

Arts and Crafts: A New Aesthetic

The first president of the Arts and Crafts Exhibition Society, created in 1887, was Walter Crane (1845–1915), an illustrator and artist but, importantly, one who sought to 'give opportunity to the designer and craftsman to exhibit their work to the public for its artistic interest and thus to assert the claims of decorative art and handicraft to attention equally with the painter of easel pictures'. Until this time there was a very distinct delineation between 'fine' and 'decorative' art in the public perception. The society floundered at first until William Morris (1834–96) took over the presidency in 1891.

A Design Revolution

Morris is often seen as the founding father of the Arts and Crafts Movement, but he was only one of a small group of people in the mid-nineteenth century who were appalled at the lack of good design practice. For them, the Industrial Revolution had corrupted sensibilities. Mass production of many items such as furniture and housewares had been ill conceived, shoddily made and often over-decorated for no purpose other than effect. This was most evident at the Great Exhibition of the Works of Industry of All Nations, held in London's Hyde Park in 1851, attended by six million people during the six months of its opening. Although seen as a cultural and financial success, the exhibition was not without its critics, particularly those with sound aesthetic judgement, including the writer John Ruskin (1819–1900), the Royal Academician Richard Redgrave (1804–88) and the designer and theorist Owen Jones (1809–74). Redgrave was the Principal at the Government School of Design, and Jones was responsible for much of the interior decoration of the Great Exhibition itself. They were critical of many of the works exhibited, and particularly scathing about the vulgar and garish designs evident in contemporary wallpapers, for example.

In 1853, as a response to the criticism, the Government School of Design became the National Art Training School, itself a forerunner of the Royal College of Art. A key player in its development was Sir Henry Cole (1808–82), who had been, along with Jones, responsible for the interior

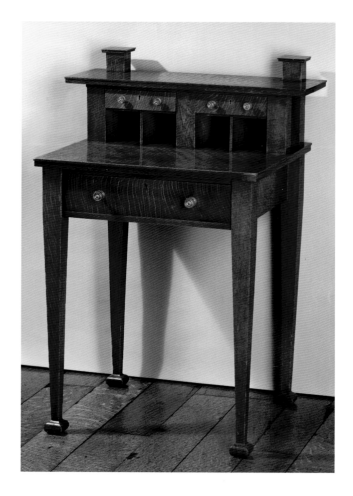

design of the Great Exhibition but who was subsequently appalled at the quality of some of the exhibited artefacts. From 1857, the school formed part of the newly opened South Kensington Museum (later known as the Victoria and Albert Museum), a repository for examples of decorative arts and design. Its first Director was Henry Cole.

With the support of Queen Victoria's husband, Prince Albert – who was responsible for overseeing the Great Exhibition – Redgrave, Jones and Cole laid down certain key principles for the development of future good design; in essence, that an object's function should dictate its form, with decoration being secondary to form. These principles formed the basic tenets of twentieth-century modernist design. Additionally, Jones, the author of *The Grammar of Ornament* (1856), advocated the use of design features that were simple and clear and that could be adapted from both non-Western and plant motifs, in stylized forms.

John Ruskin and A.W.N. Pugin

Ruskin had already established himself as a well-respected writer by the mid-nineteenth century, as an apologist for the artist J.M.W. Turner and the Pre-Raphaelite Brotherhood of artists that included Dante Gabriel Rossetti (1828–82), who was later to become a founder member of the design company headed by William Morris.

Prior to Ruskin's essays on design and aesthetics, an English architect, designer and polemicist, Augustus Welby Northmore Pugin (1812–52), had already written his key texts *Contrasts* (1836) and *The True Principles of Pointed or Christian Architecture* (1841) to demonstrate how classical architecture was inappropriate to a Christian country such as England, since its origins were in the pagan ancient worlds of Athens and Rome. Further, he believed that the division of labour was contrary to Christian morality. Pugin advocated a return to the medieval forms of craftsmanship and a 'truth to materials', central tenets of the later Arts and Crafts Movement. Pugin died at the age of 40, exhausted by the sheer output of his work. Not only did he design churches and all of their elaborate interiors but also many of the accoutrements of church life, such as the priests, vestments and Eucharistic objects. His most celebrated work is the interiors of the Palace of Westminster (also known as the Houses of Parliament), London, a masterpiece in Gothic

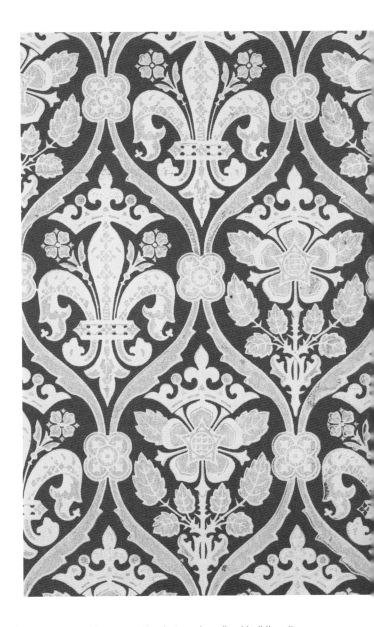

styling that paid homage to the destroyed medieval buildings it was replacing. Pugin was responsible for designing every aspect of these interiors, from the sovereign's throne chair to the floor tiles, the wallpapers to the furniture, and all the Gothic detailing of the building itself (*see* Wallpaper design for the House of Lords' library, 1840, on page 106). This was of course a secular building and interior, but beyond the associational use of Gothic styling there is very little to suggest the proclivity of Pugin's ecclesiastical work.

Building on Pugin's ideas, Ruskin wrote two treatises on architecture and design, *The Seven Lamps of Architecture* (1849) and *The Stones of Venice* (1851–53), in which he, too, proselytized about the Gothic style. Ruskin saw the effect of the separation of labour as socially reprehensible but stopped short of a return to a medieval society, which he considered feudal and inappropriate to modern Victorian Britain. Like Pugin, however, Ruskin saw Gothic as the only authentic style for Britain, although his own tastes were more eclectic and less dogmatically ecclesiastical. Ruskin expressed his social ideas in his book *Unto this Last* (1862), in which he sought to develop a moral

value in sincere labour. These ideas were distributed in the form of monthly pamphlets under the title *Fors Clavigera*, beginning in 1871. Although specifically intended to be read by the working classes, an enthusiast for these and other Ruskin works was William Morris.

William Morris

Morris was influenced by the writings of John Ruskin, who argued that the separation of the cerebral act of design from the physical act of making was socially immoral and aesthetically damaging.

Morris went to the University of Oxford to study theology with the view of becoming a clergyman, but instead became enamoured of an artistic life after attending some of Ruskin's lectures and seeing at first hand the naturalism he advocated in the paintings of the Pre-Raphaelites. Morris had also become disillusioned with the church and its lack of vibrancy. He and his fellow student – and later colleague – Edward Burne-Jones (1833–98), visited many ancient churches in the villages around the city, and were shocked and sometimes appalled at the lack of maintenance and/or inappropriate refurbishment of their fabric and interiors. Morris vowed to arrest this problem and later set up the Society for the Protection of Ancient Buildings (SPAB), in 1877. It was Burne-Jones who introduced Morris to the Pre-Raphaelite artist Dante Gabriel Rossetti.

Dante Gabriel Rossetti

Rossetti was one of the founders of the Pre-Raphaelite Brotherhood, along with John Everett Millais (1829–96) and William Holman Hunt (1827–1910). The Brotherhood was established in 1848 to reverse the mode of painting that had become 'mannered' since the sixteenth century, following the death of Raphael (1483–1520). The group was particularly critical of the style of academic painting being proffered by the Royal Academy despite, or probably because of, the fact that Hunt and Millais were students of the Academy schools. They felt that this style of painting was 'sloshy' and lax, and advocated a return to more naturalistic forms by referring to nature for inspiration. In this regard they were supported by Ruskin, who told them to 'follow nature', wrote supportive articles about them and their aims, and purchased their work.

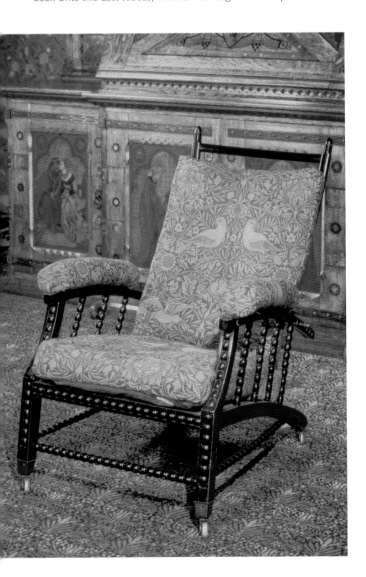

All three Pre-Raphaelite artists were initially drawn to the romanticism of medieval culture, such as the Arthurian legend, but also to reinterpret biblical narratives that used more natural contemporary models. In this morally righteous Victorian era, many of the pictures were seen as scandalous and even blasphemous since they depicted Holy figures in an informal setting, Millais' *Christ in the House of his Parents ('The Carpenters Shop')*, painted in 1849–50, being a perfect example.

William Morris was drawn to the charismatic Rossetti when they met in 1856, at a time when the artist had moved away from the ideals of his 'Brothers' in favour of a more spiritual dimension to his work. He encouraged Morris to take up painting himself; a venture that was very short lived. In the following year, Rossetti introduced Burne-Jones and Morris to his friend, the architect Benjamin Woodward (1816–61), who had recently completed the construction of the Debating Hall at the Oxford Union and asked them to decorate the interior with medieval-style frescoes.

By this time Morris and Burne-Jones had left their formal education at Oxford, with Morris joining the architectural firm of George Edmund Street (1824–81), an avowed Gothic Revivalist in the mould of Pugin. It was during his time at the practice that he met Street's assistant-architect, Philip Webb (1831–1915), who was to help Morris design his first home, Red House in Bexleyheath, Kent. Morris was later to remark that 'we understood one another at once'.

Red House

Red House, built in 1859–60, was the new house designed by Philip Webb for William Morris and his bride Jane (née Burden, 1839–1914). The house and its interior is a *gesamtkunstwerk*, or 'complete work of art', in which Morris and his artistic friends collaborated to create the seminal work of the Arts and Crafts Movement. This red brick house, in a vernacular style without pretentious ornament or façades, used local materials wherever possible, thus adhering to Ruskin's credo. When completed, his friend Rossetti remarked that it was 'more a poem than a house', while Burne-Jones hailed it as the 'beautifullest place on earth'.

Morris also began to put his own design ideas of medieval craftsmanship into practice for furnishing the house, using the talents of his fellow artist friends. For example, Burne-Jones designed the stained-glass windows and painted murals of Arthurian legends on the walls. Webb designed much of the rustic furniture made quite specifically to imitate the craftsmen's skills used in the medieval period, which were often painted by the group of artists around Morris, most notably Rossetti. Morris himself designed the garden and also hand-wove the textiles used as tapestries, curtains and other soft furnishings.

Philip Webb

After completing the project at Red House, Webb continued working with Morris as a partner in Morris, Marshall, Faulkner & Co from 1861, to which he dedicated much of his subsequent career as an Arts and Crafts designer and architect. Apart from Red House, his most notable architectural commission was towards the end of his career, in 1892 designing Standen House in East Grinstead, West Sussex, for James Beale, a prosperous London lawyer.

This house is still regarded as one of the masterpieces of Arts and Crafts design, its interiors decorated with Morris wallpapers and fabrics, and its furniture commissioned from Collinson & Lock, the leading art furnishers of the period, to designs by Webb and later practitioners such as E.W. Godwin (1833–86). In addition, Standen House was lit by electricity provided by its own generator, with some of the light fittings designed by Webb.

Webb was also instrumental in setting up the SPAB (*see* page 8) with William Morris and others in 1877 to arrest what they saw as the over-restoration of old buildings that stripped them of their patina and history. Morris referred to the organization as 'Anti-Scrape'.

Morris, Marshall, Faulkner & Co

Inspired by the initial success of working with these designers and artists around him at Red House,

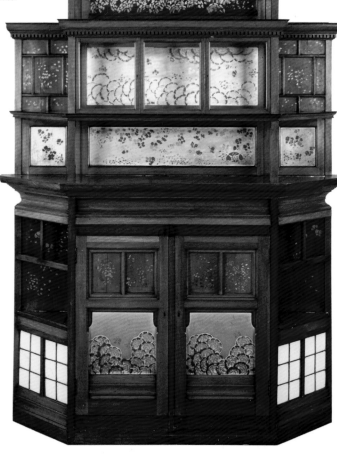

Morris established the firm of Morris, Marshall, Faulkner & Co in 1861, known thereafter as 'The Firm'. Their business premises were at Red Lion Square in London and included a basement area in which a kiln was constructed to facilitate the firing of glass and tiles. Morris anticipated that some of their clients would require domestic products, but they very quickly gained a reputation in ecclesiastical work at a time when the Gothic-style revival for church architecture was in full swing. The Firm's prospectus stated its aims as providing quality decorative arts using 'artists of repute', broadly following Ruskin's ideas about the debasing of quality in the machine age of mass production. For Ruskin, and by extension Morris, not only were the products debased but so too were the craftsmen whose livelihoods had been denigrated by the Industrial Revolution and the division of labour.

The Firm had its first success at the 1862 International Exhibition in London, creating their own version of the Medieval Court by Pugin that had been displayed at the Great Exhibition of 1851, winning two medals for their exhibits. The display was made up from pieces of furniture brought from Red House, but the most impressive of these exhibits was the stained glass designed by Rossetti that led to The Firm being commissioned to supply windows for three newly built Gothic Revival churches. They also undertook secular commissions, such as Burne-Jones's stained-glass series 'Chaucer's Goode Wimmen', which proved popular and was used in several decorative schemes, including The Combination Room at Peterhouse College, Cambridge.

It was also in 1862 that Morris created the first of his wallpaper designs *Trellis* (*see* page 107) which incorporated a floral motif intertwined within a wooden frame. Philip Webb drew the design for the birds since Morris's figurative work was not of a high enough standard. It was printed using woodblocks by the wallpaper print specialists of the time, Jeffrey & Co, with Morris taking an active participation in the process. *Trellis* and Morris's subsequent wallpaper and textile designs are very much based on Owen Jones's simplified floral motifs and Ruskin's advocacy of 'looking to nature' for inspiration.

The Firm continued to flourish very quickly, particularly after it was commissioned in 1865 to decorate and furnish the Green Dining Room at the South Kensington Museum, the first in the world to have such a facility. Morris's design scheme of blue and green provided a tranquil setting, but there was sufficient detail to provide interest for the diners. The work, which took about three years to complete, was carried out by Morris, Burne-Jones (who executed a series of astrological panels), Webb and Rossetti, and gave a huge boost to The Firm's reputation, having been executed in a more structured manner than the ad hoc approach used at Red House.

In the following decade Morris continued to expand The Firm, creating several new wallpaper designs including *Lily* (1873), *Acanthus* (*see* page 109) and *Vine* (both from 1874), and *Chrysanthemum* (1877). He and also turned his talents to printing textiles, registering three separate designs in 1875 alone: *Jasmine*, *Marigold and Tulip* and *Trellis*. In the late 1860s Morris had begun to develop handmade dyes, as he despised the commercially available aniline dyes, which he considered too garish and ill suited to the subtlety of his designs. Unfortunately, despite his best efforts Morris was unable to make his own organic dyes in sufficient quantity. In 1875, he consulted Thomas Wardle (1831–1909), brother of The Firm's general manager, George. Thomas had his own dye-making factory in Staffordshire and with Morris worked tirelessly to find the right colours using organic materials. The most difficult of these was indigo, which Wardle perfected himself. There are several recorded anecdotes of Morris experimenting with the indigo dyeing vats and having blue staining to his hands and lower arms almost permanently. He was seeking to perfect a colour as subtle as those used in Persian carpets.

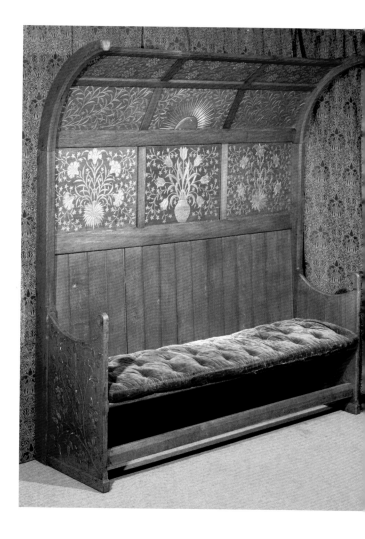

It was also in 1875 that Morris consolidated his hold on the business by dissolving the old partnership and creating Morris & Co, retaining only the services of Burne-Jones as designer. Another artist craftsman who was regularly commissioned by Morris & Co was the ceramicist William De Morgan (1839–1917).

William De Morgan

Disillusioned by his training at the Royal Academy Schools, De Morgan decided to become an artist-craftsman, after being introduced to William Morris and those of the Pre-Raphaelite circle. Having set up his own pottery works in London's Chelsea in 1872, and after a short

period of experimentation, he developed a type of reflective lustre decoration that gave his tiles and pottery an iridescent quality. De Morgan was particularly drawn to non-Western – particularly Persian – motifs, his palette being dark blue and turquoise, purple and Indian Red, unashamedly redolent of sixteenth-century Iznik pottery.

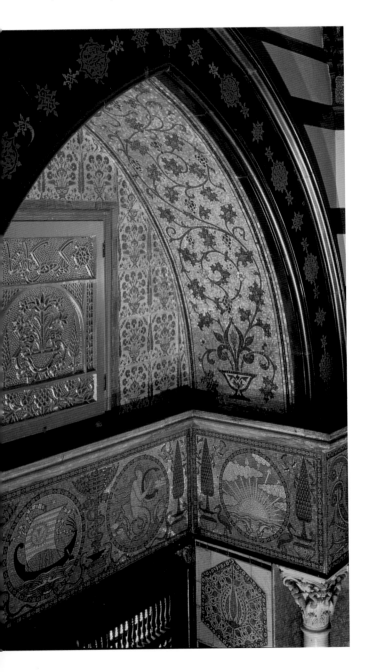

De Morgan was probably the most prolific independent designer of tiles in the last quarter of the nineteenth century, not only for Morris & Co but also for many private clients, including Lord Leighton who asked him to create a series of 'Eastern' tiles between 1877 and 1881 for the famous 'Arab Hall' at his newly built home in Kensington, London. One of his most significant clients was the P&O Steamship Company that commissioned him between 1882 and 1900 to decorate several schemes on 12 new ships, which brought him international recognition.

De Morgan is equally well known for his delicate ceramic pottery, which is also imbued with the same iridescent qualities, as shown in Tile panel depicting galleons, 1888–97, on page 64.

Expansion of Morris & Co

Enthused by the success of the printing of the first three textile designs the previous year, Morris created his most ambitious design, *Honeysuckle*, in 1876 – a particularly complex pattern, as seen on page 30. In addition to printing textiles, Morris also began weaving his own designs, beginning in 1877 with *Bird* (seen as the upholstery fabric for the chair on page 8) at his premises in Queen Square, London, on small hand-operated looms. In 1878, the Morris family moved into Kelmscott House in Hammersmith, London (named after his country retreat, Kelmscott Manor, in Gloucestershire), which not only afforded more space as a residence but also facilitated his growing interest in weaving. In addition to furnishing fabrics, Morris also embarked on designing and weaving tapestries, which he considered to be the highest and most noble aspect of weaving, as well as hand-knotted carpets.

Bird and his subsequent designs for woven fabrics, such as *Peacock and Dragon* (*see* page 31) of 1878, proved very popular as furnishing fabrics in some of the larger London homes. The demand for the woven textiles and tapestries was such that by 1881 Morris was employing weavers and needed larger premises for the operation. Transferring his premises to Merton Abbey in Surrey, Morris was able to keep up with demand, the rural location providing a relaxed and comfortable working environment, very much in line with Ruskinian ideals. In the following two years he patented six new designs including

one of his most popular, *Strawberry Thief* (*see* page 32). An added bonus for Morris was that the water from the nearby River Wandle was perfect for the dye-making process he had now perfected.

All the hand-woven and block-printed textiles were manufactured at Merton, along with the tapestries and hand-knotted carpets, while the wallpapers continued to be printed by Jeffrey & Co at their own premises. Burne-Jones had his own studios at Merton where he continued to design stained glass for both ecclesiastical and secular use. By the mid-1880s, Morris was taking less of an active part in The Firm as he became more interested in Socialism and politics. His chief designer, John Henry Dearle (1860–1932), was now responsible for the wallpaper and textile designs for The Firm, and his trusted general manager George Wardle ran the operation, while Morris's daughter May (1862–1938) became a partner in The Firm, her speciality being tapestry and embroidery.

John Henry Dearle

Seen very much as a benevolent employer, Morris had a small number of apprentices working for The Firm, including Dearle, whose talents were spotted by his employer. Dearle became the tapestry tutor to the new apprentices, but was also very adept at designing background patterns for some of Burne-Jones's figurative work in stained glass. In the late 1880s his own designs such as *Iris* (*see* page 114) were similar to those of Morris, but after 1890 he developed his own style such as in *Single Stem* (*see* page 124), an altogether more symmetrical and formalised pattern that is clearly also influenced by Owen Jones. After Morris's death in 1896, Dearle became Art Director of The Firm until his own death in 1932.

W.A.S. Benson

Another key figure before and after Morris's death was William Arthur Smith Benson (1854–1924), who helped refine some of the designs for Morris & Co in the 1890s and eventually became its Managing Director in 1896. Benson arrived at Arts and Crafts design in an unorthodox manner. Although qualified as an architect, he had always shown a talent for inventing and making things. He was encouraged to develop this talent when he came into contact with Burne-Jones and set up his own workshop in west London.

Benson applied himself to practical problems, for example making some of the light fittings used at Standen House, designed by Webb and furnished by Morris & Co. The fittings were made in copper and brass,- and Benson developed a clear lacquer to be used on them to prevent tarnishing. With one eye on future industrial manufacture, Benson remained true to the Arts and Crafts 'honesty' of exposing the basic materials used in his designs and in their manufacture.

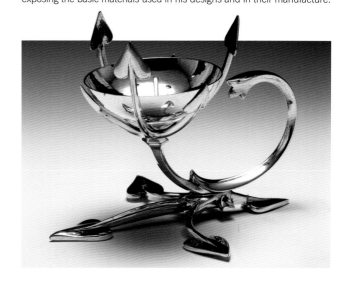

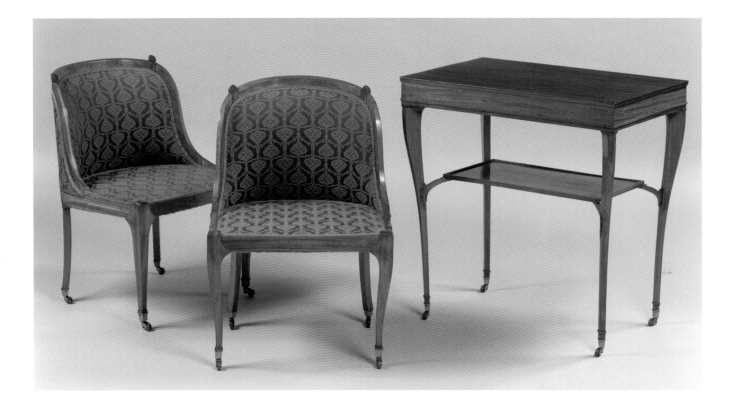

May Morris

With her father becoming more involved as a political activist, May Morris became the Director of Embroidery at Merton in 1885. She had been taught the skill by her mother and in 1881 had enrolled at the National Art Training School. After leaving, she was keen to rediscover free-form embroidery as an art, an aspiration endorsed by her father. She worked closely with Dearle, creating several designs for embroideries and tapestries, and also collaborated with her father to create a series of embroidery designs on paper that could be sold as part of home-embroidery kits. *The Flower Pot* (*see* page 81) is one such example.

In 1907 May Morris set up the Women's Guild of Arts, as the Art Workers' Guild did not accept female members. Not only was she its President until 1935, but she also played an active part in The Royal School of Art Needlework, becoming an influential embroiderer and jewellery designer.

Change of Style

By the 1880s the enthusiasm for the Gothic Revival as a decorative style was waning but its ethos was very much alive. Although 'Arts and Crafts' was not used as a generic term until the end of the decade, the notion of hand-craftsmanship was a template for a more humane society that eschewed factory mass production as a social evil. Ruskin himself had tried to formulate his ideas in 1871 when he founded the ill-fated Guild of St George but his disciple, Arthur Heygate Mackmurdo (1851–1942), was more successful.

Arthur Heygate Mackmurdo

Mackmurdo came from a privileged family background and was fortunate enough to travel with John Ruskin on one of his visits to Italy in 1874. On his return, Mackmurdo set up his own architecture and design practice in London. His best-known house design was for the writer and illustrator Mortimer Menpes (1855–1938), built in London's Chelsea district on

rectilinear lines, reflecting the new style for a Japanese aesthetic. Its interior was also designed in the same style, which subsequently became known as Aestheticism. Mackmurdo also designed furniture, including the chair named after him that anticipates the Art Nouveau style.

The Century Guild of Artists

The guild, the first of its kind in the Arts and Crafts Movement, was founded by Mackmurdo in 1882 and was active between 1883 and 1892 with the aim of promoting the work of the authentic designer/craftsman. The guild produced essentially domestic-designed furniture, stained glass, metalwork, decorative painting and architectural design, gaining its reputation and that of its associates through exhibiting. The group also published a quarterly magazine called *The Hobby Horse,* which ran from 1884–94. *The Hobby Horse* served as a way of sharing the views of the guild and promoted craftsmanship as an alternative to mass-produced items made by mechanized industry.

Independent Designers and Groups

The Century Guild inspired other independently minded designers to form mutually beneficial groups, most of them regional; but more importantly, as the style gained momentum many designers felt confident enough to become completely independent of groups. Among these were Christopher Dresser (1834–1904) and Lindsay P. Butterfield (1869–1948).

Aestheticism

Owen Jones had already identified the need to look beyond Western sources for design inspiration in the 1850s, but it was with the opening of Japan's trading borders in the 1860s that the Western world developed a taste for all things Japanese. After an initial flurry of paintings depicting Western notions of 'Orientalism', and the import of Japanese *objets d'art* for the masses, the more seriously minded

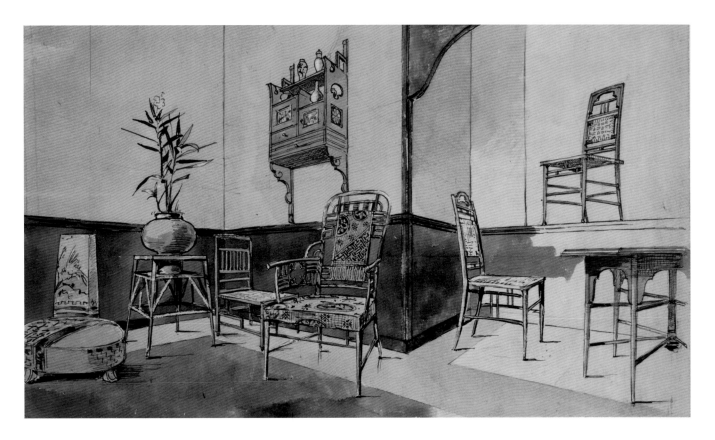

students of the Japanese aesthetic adopted some of its ideals of linearity. Among the first exponents of this aesthetic was Christopher Dresser, who had travelled extensively in Japan during 1877.

The Aesthetic Movement, as it came to be known, was developed as an art and design sensibility devoid of moral or political purpose, in favour of one that emphasized the beauty of the object itself. The forms were often simplified and elegant, and paid homage to the Movement's Japanese influence. Aesthetic Movement furniture, for example, emphasized the simplicity of the item by using minimal colour (usually ebony) and decoration, as well as clear rectilinear vertical and horizontal lines. Used often as an accessory to the furniture would be contemporarily made delicate and simplified porcelain ware; De Morgan was particularly adept at this kind of art porcelain.

Christopher Dresser and Lindsay P. Butterfield

Dresser was not an Arts and Crafts practitioner *per se*, since he was not actually a craftsman, but his designs and his writings had a profound effect on design reform. In fact, he was trained as a botanist and made a detailed study of the geometry of plants. He is often described as the first 'industrial' designer, despite the fact that craftsmen executed his designs for silverware, glassware and furniture. His mentor at the Government School of Design, which he attended as a student from 1848, was Owen Jones, and Dresser contributed some illustrations to Jones's 1856 *The Grammar of Ornament*. Several Arts and Crafts practitioners also adopted ideas of 'Japanese' linearity, including Charles Rennie Mackintosh (1868–1928), Ernest Gimson (1864–1919), Josef Hoffmann (1870–1956) and Frank Lloyd Wright (1867–1959). Butterfield also took up Dresser's study of plant forms for his own designs.

Butterfield was a freelance designer of textiles and wallpapers. The design for *Tiger Lily* (*see* page 47) was created in 1896, the year William Morris died. In many ways the design encapsulates a central tenet of Morris's belief that if the designer has to create a design specifically to be used in a mechanical process, then it should at least be a strong but simple pattern. In his words 'make it mechanical with a vengeance'. The design is also one that Ruskin would have approved of, since it is inspired by natural forms. Butterfield trained at the National Art Training School, making a detailed study of the geometry of plants that he adapted well in these stylized patterns.

Ernest Gimson

Gimson's furniture has all the hallmarks of both Arts and Crafts workmanship and the linearity of Aestheticism, his cabinet of 1902 being a prime example (*see* the cabinet in the image right). Although the earlier Arts and Crafts ideals of 'truth to materials' were a thing of the past, and the designer opted to use veneer inlays to decorate the work, nevertheless, this work is rooted in the Arts and Crafts

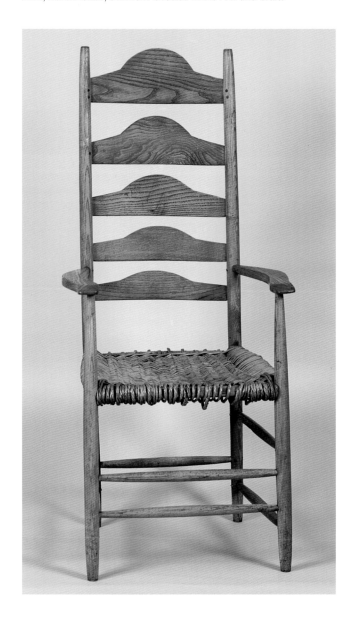

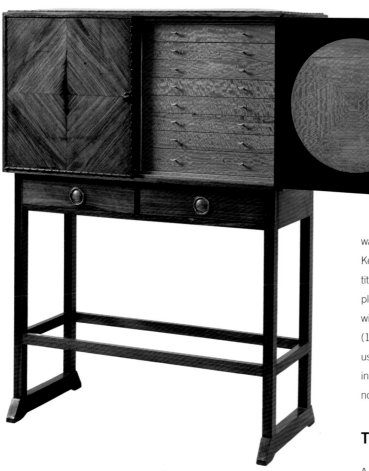

The Kelmscott Press

The Century Guild of Artists also promoted the ancient craft of letterpress printing, which for most books had been overtaken on an industrial scale by mechanical printers. From his student days in Oxford, William Morris had collected medieval books and manuscripts and was enamoured of their craftsmanship, leading to him setting up his own Kelmscott Press in 1891. The first book he produced was one of his own titles, *The Story of the Glittering Plain* (1891). Encouraged by the pleasure this gave him, he created his own 'Golden' typeface and worked with Burne-Jones on an edition of *The Works of Geoffrey Chaucer* (1896). In addition to the literary works of history and myth, Morris also used the press to publish his own novel, *News From Nowhere* (1892), in which the central character dreams of living in a futuristic Utopia with no class divisions, a society in which it is a joy to work.

of the Earl of Bathurst and created many pieces of furniture that were imbued with the rural craftsmanship of the region.

The Art Workers' Guild

A small group of 'artist practitioners' formed the Art Workers' Guild in 1884, led by Walter Crane. Crane was essentially an artist and illustrator of children's books, but was also one of a number of independent designers who were designing for mass markets in a considered Arts and Crafts manner, using stylized flora and fauna for wallpapers and textile manufacture for the burgeoning middle classes. Another independent 'industrial' designer was Lewis Foreman Day (1845–1910), a contemporary of Crane and a member of the guild. Day was a prolific designer of pattern, which he applied to textiles and wallpapers. He was a superb draftsman too, creating designs for tiles and art pottery, clocks, furniture, stained glass and interiors of incredible diversity (*see Wisteria*, decorative panel, *c.* 1890 on page 88). Moreover, he embraced modern technology and passionately believed that in order to produce beautiful things in the future for the majority rather than the minority, designers and industrialists would have to be made to work together.

Movement. Gimson was not a craftsman in the traditional sense of the word, but graduated from the Leicester School of Art before becoming an apprentice to the architect John D. Sedding (1838–91), who specialized in church architecture. Sedding's offices were next door to the premises of Morris & Co, which was often commissioned to provide many of the decorative details for his churches. Gimson took full advantage of the proximity to Morris & Co to see the craftsmanship of its work. Later in his career, and in homage to Morris, Gimson created a number of cottages and a village hall at Kelmscott village, in Gloucestershire, where Morris had his country home, Kelmscott Manor.

In the 1890s Gimson became interested in learning craftsmanship skills and moved to the Cotswolds with two former business associates and craftsmen, the Barnsley brothers. Here they enjoyed the patronage

The aim of the guild was to create widespread social contact and interaction between different artistic disciplines and to blur the boundaries between fine and applied arts. This was to be an open forum for discussion and debate about good art and design practice for the benefit of all, irrespective of political ideology and stylistic preferences. Many of the Arts and Crafts practitioners became members, since they already wished to uphold the highest standards of design and craftsmanship, although its membership was restricted and only open to men. Among their number were Burne-Jones and Mackmurdo, as well as newer practitioners such as Charles Francis Annesley Voysey (1857–1941) and Charles Robert Ashbee (1863–1942). William Morris was not one of the founding members but he was appointed its Master in 1892.

Part of the remit of the guild was education, and when in 1890 the newly formed London County Council set up certified training courses in design and architecture, with the emphasis less on theory and more on practical skills, some of its members such as William R. Lethaby (1857–1931) were very active instructors.

The guild began to exhibit the work of its members, a role subsequently taken over by The Arts and Crafts Exhibition Society from 1888. Their first exhibition was held at the newly opened New Gallery in London's Regent Street and, although the exhibitions continued up until the mid-twentieth century, they became less popular as interest in Arts and Crafts waned as the nineteenth century turned.

The Guild of Handicraft, 1888

Based on the ethics of John Ruskin and the socialist ideals of William Morris, C.R. Ashbee set up the School and Guild of Handicraft in 1888. Its workshops were based in London's poor and deprived East End to provide skills and work opportunities for the local population, although the retail outlet was in fashionable Mayfair, close to its patrons. Operating as a co-operative, its stated aim was to 'seek not only to set a higher standard of craftsmanship, but at the same time, and in so doing, to protect the status of the craftsman'. Unfortunately, the school closed in 1895 due to what Ashbee referred to as state interference, justifiable perhaps considering that in the following year the London County Council

opened its Central School of Art and Design, which undercut his fees. The workshops, however, continued to prosper, finally moving the operation in 1902 from London to Chipping Campden in the rural district of the Cotswolds. The premises were much larger than those in London and provided a much healthier environment for his staff to work in. At one time, Ashbee had in excess of 40 craftsmen specializing in leatherwork (*see* Decorative panels, 1892 on page 90), silver metalworking, jewellery and enamels, hand-wrought copper and ironwork, as well as furniture. The venture lasted for five years before the guild was forced into liquidation due to a fall in demand.

C.R. Ashbee

Arguably more than any other Arts and Crafts practitioner, Ashbee comes closest to following William Morris's ideals. In fact, it would be hard to distinguish Ashbee from the whole ethos of the Arts and Crafts Movement, both in craftsmanship and socialist ideals. Like Morris, he came from an affluent background, being educated at a private school and then at the University of Cambridge before joining the architectural practice of George Frederick Bodley (1827–1907) in 1886. Bodley was an avowed Gothic Revivalist and completed many ecclesiastical commissions, with Morris & Co creating much of the stained glass used on his schemes.

At the time of his apprenticeship under Bodley, Ashbee was living in Toynbee Hall in London's deprived area of Whitechapel. Toynbee Hall was a charitable organization that encouraged university graduates to help in the education of those less fortunate, and the ethos of the charity was for social reform, bringing together the affluent and deprived to share a common goal: the eradication of poverty. The charity is still in existence. Ashbee had read

Ruskin's works while still at university but was now able to attend Morris's lectures on social reform at the Hammersmith branch of The Socialist League.

Ashbee organized evening classes for boys and men from the slum districts of London's East End, and many of them became proficient craftsmen, enabling him to set up his first Guild of Handicraft. He passionately believed that craftsmen could be taught art and design theory alongside actual production of the objects, a departure from more conventional study practices. In turn, this would develop camaraderie in the workshop, making it an enjoyable environment in which to work.

Ashbee's designs are unique and legendary in the Arts and Crafts Movement. He is best known for his precious metal designs such as the salt cellar (*see* left), and his exquisite jewellery (*see* the brooch, right). His designs are a departure from the highly finished and polished industrially made silverware contemporary to the time. Ashbee and the guild offered an alternative that revealed the craftsman's marks, for example a hammered finish. In this way, according to Ashbee, the craftsman is in contact with its subsequent owner. Other innovations of Ashbee's *oeuvre* were the application of semi-precious stones and 'found objects' on to the work.

Ashbee is equally well known for his unusual furniture designs, often incorporating unusual veneer inlays (*see* the cabinet on page 17) and applied metalwork. After William Morris's death in 1896, and the discontinuation of the Kelmscott

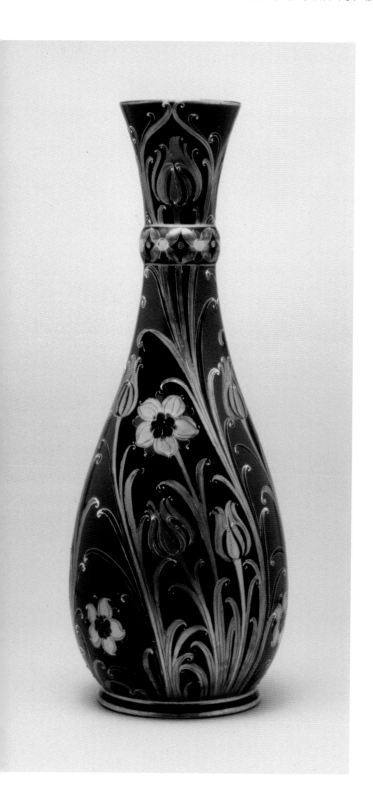

Press, Ashbee set up the Essex House Press in 1898, using staff from the former venture. By the time it closed in 1910, it had printed and published more than 50 titles.

Following the demise of the guild, Ashbee remained committed to the ethos of the Arts and Crafts Movement, but realized that the future lay not in handcrafted items for what Morris termed the 'swinish rich' but to create good design that can be manufactured to exacting standards. In this regard, Ashbee advocated the idea that industry needed to forge links with designers prior to the manufacturing process. Thus, both Ashbee and Morris recognized the role of good design matching the requirements of a modern and rapidly changing consumer society.

Liberty & Co

One of the Guild of Handicrafts' main competitors in an increasingly consumer-led society was Liberty & Co. Established by Arthur Lasenby Liberty (1843–1917) in 1875, this new department store quickly began selling decorative, well-made items to the burgeoning middle classes of late Victorian England. The 'Liberty style' emanated from its policy of retaining the anonymity of its designers. Stylistically there are similarities, for example between Ashbee's silver wares and the *Cymric* line as designed by Archibald Knox (1864–1933) for Liberty & Co that often included semi-precious stones as embellishments (*see* the belt buckle on page 6). Many of Liberty's designs were closely linked to the Aesthetic Movement and the taste for *Japonisme*. Liberty aimed to combine 'utility and good taste with modest cost'. Eventually Liberty & Co became synonymous with the vogue for Art Nouveau styling, the precursors of which were members of the Arts and Crafts Movement such as Walter Crane and Arthur Mackmurdo.

Liberty & Co offered a whole range of items from furniture and soft furnishings to tableware and *objets d'art*. However, the fact that it retained the anonymity of the designers in favour of the 'Liberty style' trivialized as well as popularized Arts and Crafts as an aesthetic style. Nevertheless, many Arts and Crafts practitioners were able to sell their designs to Liberty to be made in larger quantities than those that could be produced by artisan craftsmen. These included William De Morgan, who towards the end of his life was unable to actually produce his tiles

and pottery due to ill health, but continued designing. However, by the twentieth century Liberty & Co became less reliant on De Morgan and turned its attention instead to William Moorcroft (1872–1945), who had set up his own factory making art pottery (*see* the gilded vase, left).

Another designer who benefited from the Liberty & Co anonymity clause was Charles Voysey.

C.F.A. Voysey

Like so many Arts and Crafts practitioners before him, Voysey was apprenticed to a Gothic Revival architect, in this case John Pollard Seddon (1827–1906), whose most famous work is University College Wales at Aberystwyth (1872). Voysey spent six years with Seddon, but it was as an assistant to George Devey (1820–86) in 1880–81 that his architectural and design work is most indebted. Devey worked for several aristocratic and wealthy families, including the Rothschilds, creating and enlarging existing vernacular homes that had an organic look to them. Devey adapted and used materials from different eras to create the illusion that these were enlarged over centuries rather than in one period. Ascott Hall in Buckinghamshire is a prime example.

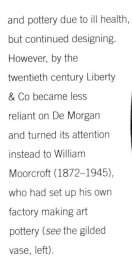

In 1894 Voysey opened a practice in London next door to his contemporary, Edward Schroeder Prior (1857–1932), another Arts and Crafts architect whose mentor was Philip Webb. The two men enjoyed a lifetime friendship and exchange of ideas. Between 1893 and 1910 Voysey designed many houses in a vernacular style that have his own very distinctive Arts and Crafts hallmark on them, such as high pitched roofs, tall chimney stacks and large windows to create an airy and light feeling internally. Voysey believed that a home should have 'all the qualities of peace and rest and protection and family pride'. His houses pay no reference to historical motif and yet are synonymous with the English countryside. In essence they are both picturesque and progressive, although Voysey would have eschewed any suggestion his work was 'modern'. Among his best-known designs is New Place in Haslemere, Surrey, designed in 1897 for A.M.M. Stedman (later known as Sir Algernon Methuen).

Prior to his architectural venture, Voysey was involved in wallpaper design. In 1883 he was introduced to Jeffrey & Co by Mackmurdo, and also designed for other leading wallpaper manufacturers, most notably Essex & Co with whom he developed a regular contract. It was, however, his textile designs in which he most utilized his favourite motifs: birds and flowers (*see* Flowers and Leaves with Birds, *c.* 1893 on page 44).

Voysey was also adept at designing furniture, which like his architectural designs is very distinct, often using a 'heart' motif in the cabinet's metalwork. His early designs were adopted anonymously by Liberty & Co, but later he incorporated furniture with complete interiors for his architectural clients, an example being The Homestead at Frinton-on-Sea in Essex (1905–06) for Sydney Claridge Turner.

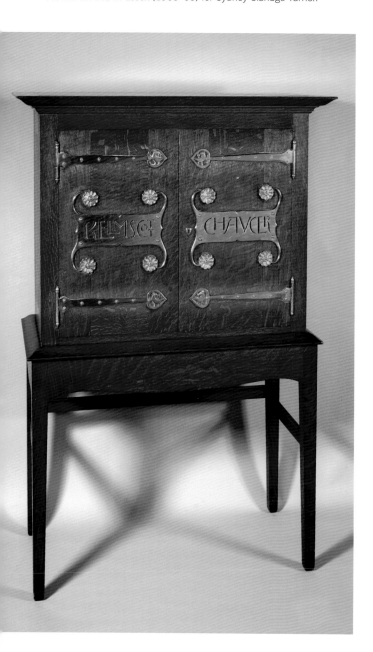

Voysey incorporated the use of linear forms similar to those used by other Aesthetic Movement designers influenced by Japanese interiors. For Voysey, the horizontal represented repose and rest while the vertical symbolized energy and dynamism, as exemplified in many of his interior staircase arrangements and most notably at his own home, The Orchard, from 1899.

Arguably more than any other Arts and Crafts designer, Voysey was the most versatile practitioner of them all, the all-round designer. Apart from wallpaper and textiles, he produced designs for Minton Tiles and Pilkington Tile and Pottery Company. He designed carpets for Heal's department store as well as textiles for Liberty & Co, and even electric light fittings. Voysey was one of a new breed of late Arts and Crafts designers, who although they were not necessarily craftsmen were very versatile designers for the new modern age.

The Arts and Crafts Movement at the End of the Century

A contemporary of Voysey was the architect William Lethaby who, unlike others in the Arts and Crafts profession, was not trained by a Gothic Revivalist. Instead, his talents were recognized by the architect and Royal Academician Richard Norman Shaw (1831–1912), who had developed a particular style that was referred to inaccurately as 'Queen Anne'. His most celebrated works are New Scotland Yard in London (1890), and Cragside (1869–85), a vernacular-style residence in Morpeth, Northumberland that has aspects of the Arts and Crafts. In this latter project, Lethaby became his assistant; he stayed with Shaw until 1892, although much of this was on a part-time basis as he sought to develop his own practice.

Joining the Society for the Protection of Ancient Buildings, he met William Morris and shared his political ideals. His output of architecture was small compared to that of Voysey but he set up a furniture-making business called Kenton & Company with Ernest Gimson. Lethaby's main contribution to the Movement was, however, in education, founding the Central School of Arts and Crafts under the control of the London County Council in 1896. His most significant contribution was to break down the barriers between design (previously perceived as a

cerebral function) and production (which was seen as functional and artisan). Lethaby believed that both disciplines needed to be taught equally to designers working in the modern world, anticipating the Bauhaus ethos by 20 years.

A fellow lecturer at the Central School for its first two years was Alexander Fisher (1864–1936), who taught enamelling. Fisher was also a silversmith and an example of his work can be seen in The Peacock Sconce, *c.* 1899 on page 95.

Charles Rennie Mackintosh and The Glasgow Four

Another architect who anticipated the Modern Movement was the Scottish designer Charles Rennie Mackintosh. His work perfectly exemplifies turn-of-the-century sensibilities in the fusion of Aestheticism, Arts and Crafts and as a pioneer of the Modern Movement. Mackintosh's most significant work was the new Glasgow School of Art building, designed in 1897.

In 1892 he was introduced to the sisters Margaret (1865–1933) and Frances (1873–1921) Macdonald at the Glasgow School of Art, and together with Herbert MacNair (1868–1955) they made up a group of artists and designers that became known as 'The Glasgow Four' (or 'The Four'). At this time Glasgow was an important dockland city for imported goods entering Britain from overseas, most notably Japan. Glasgow was on a par with London and Paris in embracing *Japonisme*. Mackintosh was enamoured of the Japanese aesthetic and began to adopt the rectilinear style in his own designs for chairs, cabinets and decorative schemes, most notably at Hill House, Helensburgh (1902–04) and The Willow Tea Rooms, Glasgow (1903).

Margaret Macdonald also worked in the Arts and Crafts style but was more interested in reviving Celtic motifs as part of her *oeuvre*, in embroidery, textiles and decorative panels, often using the latter as part of Mackintosh's schemes. They were married in 1900 and in the same year were visited by the wealthy Viennese banker Fritz Wärndorfer (1868–1939). Seeing the work of The Four, he invited them to exhibit their work in the forthcoming Vienna Secession exhibition of 1900.

It was very well received and influenced the work of Koloman Moser (1868–1918) (one of his cabinets can be seen on page 23) and Josef Hoffmann (see an example of his work, a table, right) who were instrumental in setting up the Wiener Werkstätte in 1903, based on Arts and Crafts ideals.

Mackay Hugh Baillie Scott

Another independent architect and designer who developed his own Arts and Crafts style was Mackay Hugh Baillie Scott (1865–1945). Scott learned his profession at the Isle of Man School of Art, and became fascinated and inspired by Manx traditions, setting up his own practice on the island. Like Voysey, Scott designed everything for his homes, both external and internal, with no detail too small to concern him (see his Embroidered panels, 1903, on page 101). In 1894 he proposed a design for an 'ideal home' that was published in the new journal *The Studio*, bringing him many commissions and leading to well over 200 completed schemes. His most well-known house is Blackwell in Cumbria (1901) that also contains decorative tiles by William De Morgan.

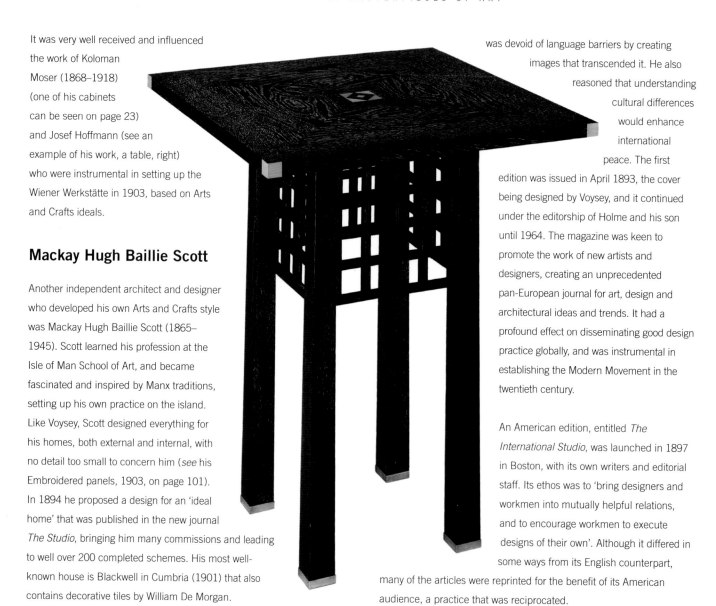

The Studio Magazine

Aiding the development of the Arts and Crafts Movement, its aesthetic and contemporary design trends were promoted through a monthly journal known as *The Studio*, which was founded in 1893 by Charles Holme (1848–1923). Holme was in the wool and silk trade, had travelled extensively in Europe and had visited Japan and the United States with Arthur Liberty, with whom he discussed the idea of an art magazine that

was devoid of language barriers by creating images that transcended it. He also reasoned that understanding cultural differences would enhance international peace. The first edition was issued in April 1893, the cover being designed by Voysey, and it continued under the editorship of Holme and his son until 1964. The magazine was keen to promote the work of new artists and designers, creating an unprecedented pan-European journal for art, design and architectural ideas and trends. It had a profound effect on disseminating good design practice globally, and was instrumental in establishing the Modern Movement in the twentieth century.

An American edition, entitled *The International Studio*, was launched in 1897 in Boston, with its own writers and editorial staff. Its ethos was to 'bring designers and workmen into mutually helpful relations, and to encourage workmen to execute designs of their own'. Although it differed in some ways from its English counterpart, many of the articles were reprinted for the benefit of its American audience, a practice that was reciprocated.

European Arts and Crafts

Many of the Arts and Crafts ideas promoted by the British practitioners in *The Studio* came to the attention of their Continental counterparts. Like the British, they too were often dismayed and frustrated that 'craft' was not given the same level of respect as fine art, and further that there was too much state control over the aesthetic. The first to 'secede' from state patronage was a group of artists in Munich, who in

1892 collectively became members of the 'Association of Visual Artists of Munich', later known as the Munich Secession. A number of them were designers, including Hermann Obrist (1862–1927) and Peter Behrens (1868–1940). They, and a small group of others, went on to form the Vereinigte Werkstätten für Kunst in 1898, a name that was derived from Morris's 'branded workshops' in his Utopian novel *News From Nowhere*. That said, they did not share Morris's ideals of a rural workshop but wanted to align themselves with his design ideals, namely an item's simplicity and its fitness for purpose.

Hermann Muthesius (1861–1927), a trained German architect, was given a posting to London as cultural attaché to investigate domestic life in England, which inevitably brought him into contact with the Arts and Crafts Movement, of which he approved. He admired the modest functionality and honesty to materials as an alternative to the German predominance of ostentatious historicism that had plagued his country in much the same way as it had in Britain in the nineteenth century. He did not approve of Morris's ideas that goods should be handmade, as this was elitist. He did, however, approve of Benson's design ideas that could be proto-typed and then designed for mass production under strict quality control. Muthesius was, of course, referring to the ambiguity of the Arts and Crafts Movement, reconciling the socialist ideas of well-made objects being affordable by more than just an elite.

In 1899 Ernst Ludwig, the Grand Duke of Hesse (1868–1937), established an artists' colony – the Darmstadt Kunstlerkolonie – in Germany, bringing together artists, designers and craftsmen from across Europe to create a community in the 'new style'. The leading lights of this venture were Behrens and a Viennese designer, Joseph Maria Olbrich (1867–1908), who had already made his name as a founding member of the Vienna Secession set up in 1897.

Originally the houses to be created at the colony were to be occupied by the artists themselves. Behrens and Olbrich both designed their own houses in an Arts and Crafts style, along with some others, but not all the artists summoned to Darmstadt were able to afford the construction costs. Once completed, the first Darmstadt artists' colony exhibition, entitled *A Document of German Art*, was held in 1901, for which the

houses and their interiors were the focus. The British designers Baillie Scott and Mackintosh both won awards for their displays. Much of the design work – both internal and external – at the exhibition was a crossover between Arts and Crafts and *Jugendstil* or Art Nouveau styles.

Shorty after the 1901 exhibition Behrens left Darmstadt, wishing to move away from the *Jugendstil* aesthetic and concentrate instead on industrial design, becoming Director at the *Kunstgewerbeschule* (School of Arts and Crafts) in Düsseldorf. It was in 1907 that he and a group of others, including Olbrich, under the directorship of Muthesius, set up the famous *Deutscher Werkbund* (German Association of Craftsmen) to establish a partnership with leading manufacturers. Although clearly indebted to the principles of the Arts and Crafts Movement, these designers wanted to focus on improving the design aesthetic of everyday objects that could be produced on an industrial scale. Behrens's subsequent work for AEG is a prime example.

Another member of the *Deutscher Werkbund* was Josef Hoffmann (*see his design for the Concordia Ball programme, right*), an architect and designer who in 1897 set up the Viennese Secession group of artists and

designers with Koloman Moser and Olbrich who designed their exhibition building in Vienna. Hoffmann and Moser then set up the Wiener Werkstätte in 1903, an architectural practice with additional workshops producing fine metalwork and bookbinding. In essence, they wanted to create *gesamtkunstwerk*. Hoffmann's Palais Stoclet of 1905–11 is exemplary. Within two years the Werkstätte had expanded exponentially to include jewellery, enamelling, ceramics and even a furniture workshop. Hoffmann and Moser scrutinized everything to ensure that only products of the finest quality left the premises. That extended also to outside contractors who eventually were used more regularly for the furniture in particular, since their own workshops had limited capacity.

As the move towards designing for industry began to gather momentum, it was necessary for designers such as Hoffmann to become involved with leading industrialists to produce work on a larger scale, hence his involvement in the Werkbund.

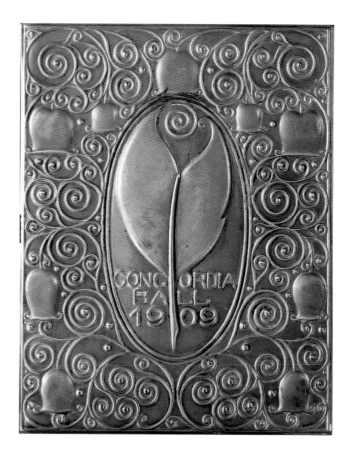

The American Arts and Crafts Movement

In the United States, the Arts and Crafts Movement was also shaped by the writings of Ruskin and Morris, who were among their bestselling authors. Although neither visited the country, several of their disciples did, including May Morris and Ashbee. There were a number of expositions in several major cities, beginning in 1876, displaying the work of British craftsmen. The Society of Arts and Crafts in Boston was set up in 1897 to promote the aesthetic, and their journal *Handicraft* was one of several at this time that could provide illustrations. The first practitioner of note in America was Gustav Stickley (1858–1942), who produced a range of furniture that came to be known as 'Mission Style'. In essence, the furniture was simply made from oak with a strong emphasis on vertical and horizontal lines. Stickley also produced a popular journal called *The Craftsman*, leading to the Arts and Crafts aesthetic being known as 'Craftsman Style'.

Another practitioner was Frank Lloyd Wright, who developed the so-called 'Prairie' style houses from 1900. There are several well-known examples of these, including The Willits House (1901) near Chicago. Their common features include the rustic look, often with exposed timbers, large windows and an emphasis on rectilinear lines, which is indebted to Wright's study of Japanese design. They often have large overhanging roofs and prominent chimneys, not dissimilar to those designed by Voysey. Like Voysey, Wright paid attention to all the details including the interiors, which contained furniture designed by him, again with a very rectilinear aesthetic. As the century progressed, Wright, like most progressive architects, began to embrace Modernism, for example in the use of pre-fabricated concrete in the 1920s. His design for the

Guggenheim Museum in New York (commissioned in 1943 and opened in 1959) is about as far away from the Arts and Crafts aesthetic as it is possible to get.

The Legacy of the Arts and Crafts Movement

There was a general move away from the Arts and Crafts style on the Continent and in the United States as the twentieth century progressed, as it was perceived to be rather 'old-fashioned' and impractical. In its place came the new 'International Style' where homes became 'machines for living in'. In Britain, contrary to this shift, the Arts and Crafts style continued, particularly in residential architecture. The taste for the 'mock Tudor' house in the 1920s and 30s was as much about a sense of nostalgia following the carnage of the First World War as adhering to the spirit of Arts and Crafts, nevertheless the interiors of these houses were still essentially Arts and Crafts, as people continued to use Liberty & Co for their decoration and furnishings, while Morris & Co continued in business until the Second World War.

The development of modern technologies, such as radio, also facilitated the manufacture of cabinets to house them. Although it was now possible to buy 'Bakelite' versions at a lower price, the wooden cabinets made by Gordon Russell (1892–1980) in the Cotswolds proved very popular for the more discerning. Russell also made a complete range of furniture and furnishing fabrics in a simplified modern style but with all the attributes of craftsmanship.It is now well over 100 years since the Arts and Crafts Exhibition Society was created. Today it exists as the Society of Designer Craftsmen (SDC) that continues to hold an annual exhibition in central London. Its mission statement is 'to promote and support the work of creative thinkers, designers and makers who continue to innovate in the crafts through their exploration of materials and skills'. Ruskin would have been pleased.

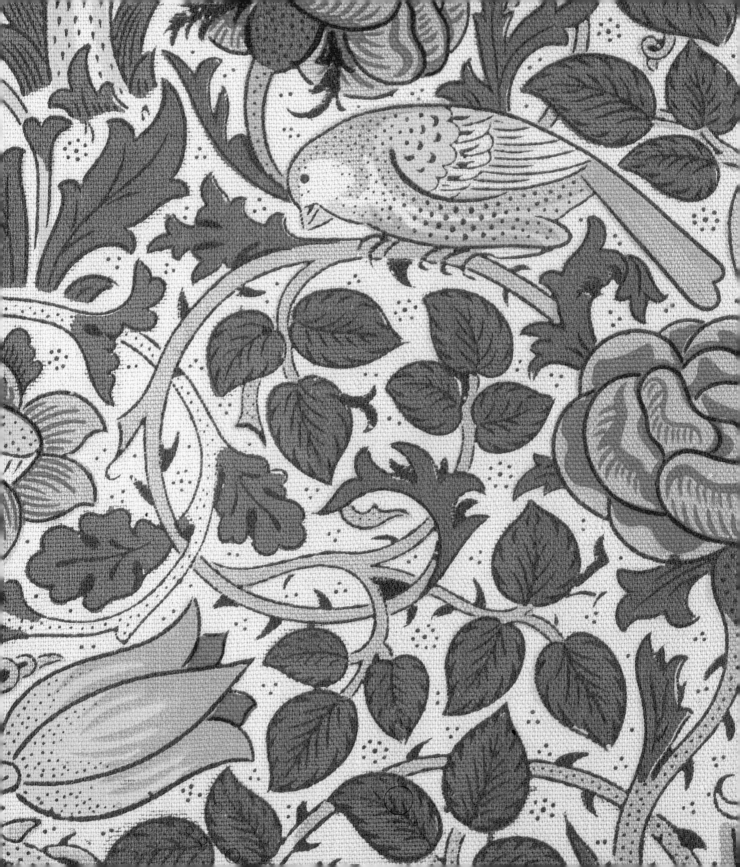

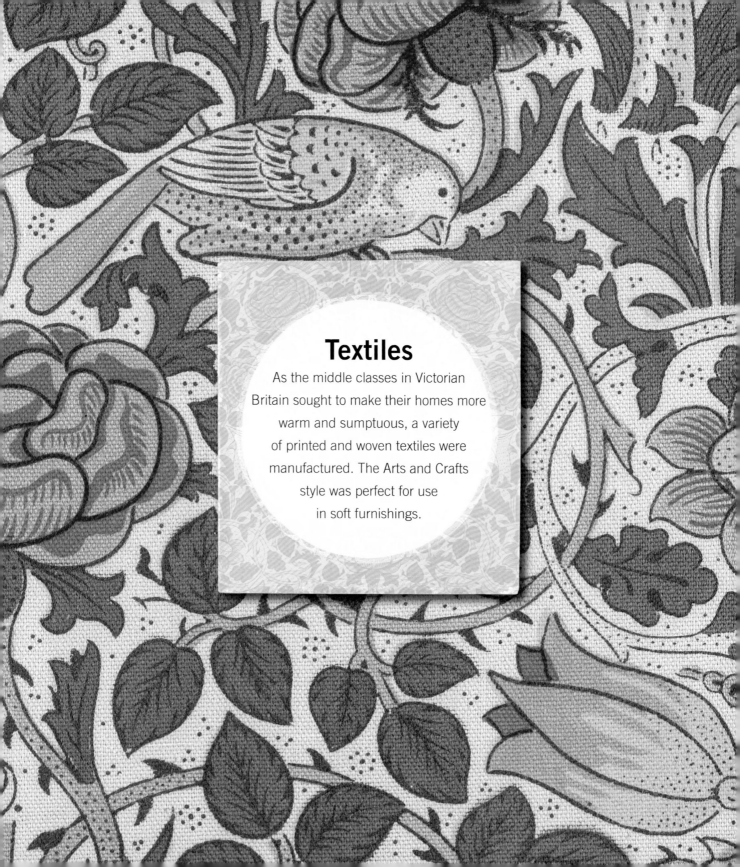

Textiles

As the middle classes in Victorian Britain sought to make their homes more warm and sumptuous, a variety of printed and woven textiles were manufactured. The Arts and Crafts style was perfect for use in soft furnishings.

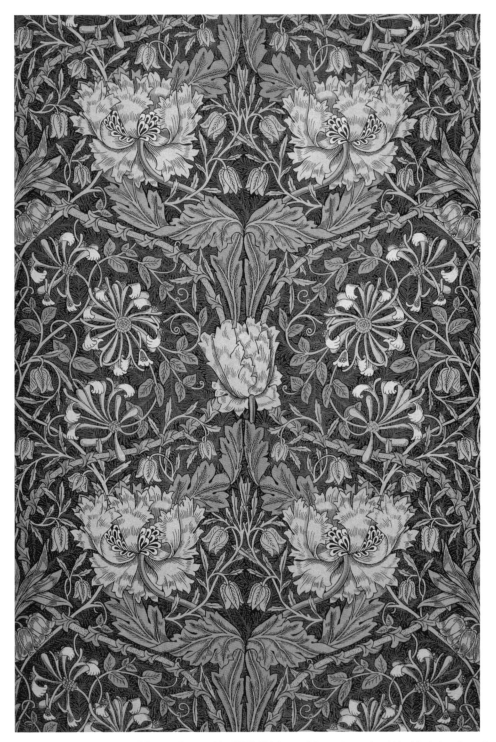

William Morris (1834–96)
Block printed on cotton • Private Collection

Honeysuckle, 1876. This is one of the most complex of Morris's designs for textiles, which was first printed experimentally on uncoloured silk. This version on cotton differs in colouring from the silk, as it is on a charcoal background that highlights the pink.

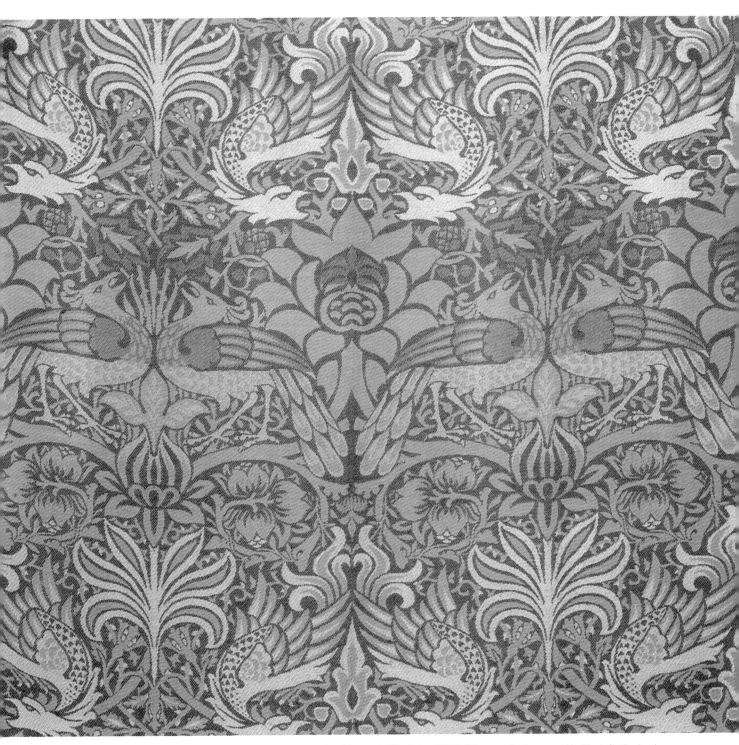

William Morris (1834–96)
Woodblock print • Private Collection

Peacock and Dragon textile design, 1878. This woven fabric was used by Morris for the drawing room at Kelmscott Manor as a curtain fabric and proved very popular commercially. The design is based on fifteenth-century Sicilian designs that Morris probably saw at the South Kensington Museum.

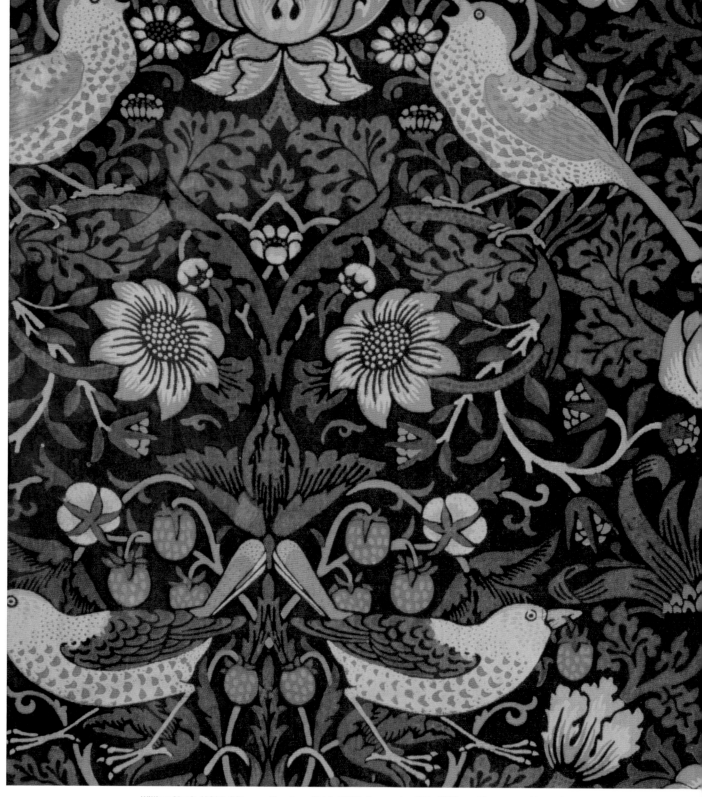

William Morris (1834–96)
Printed cotton • Private Collection

Strawberry Thief, 1883. It was not until the 1880s and the move to Merton Abbey that Morris was able to perfect the technique of 'indigo-discharge' to create printed textiles such as this one. The method was very labour intensive.

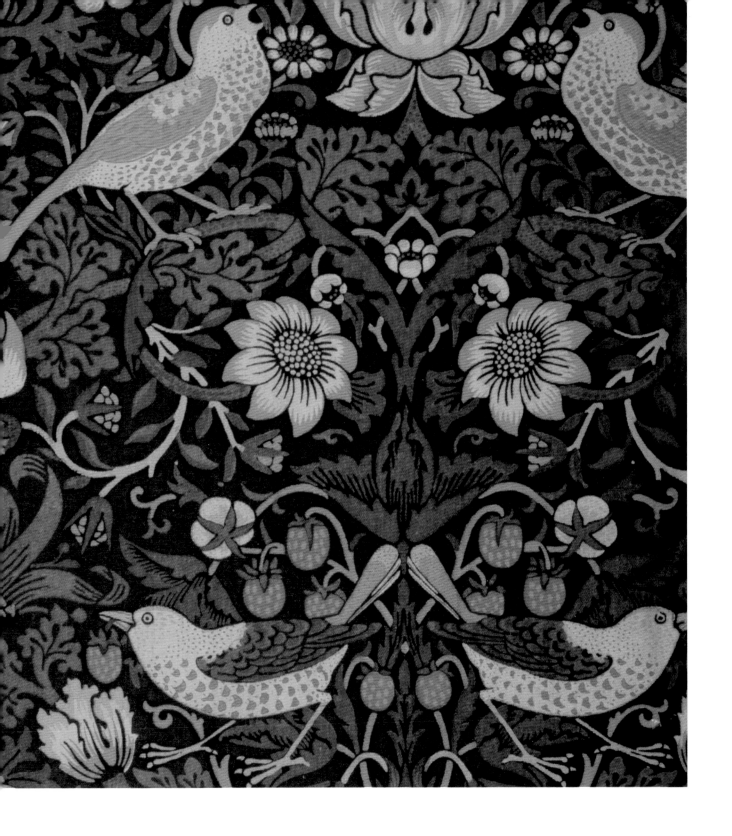

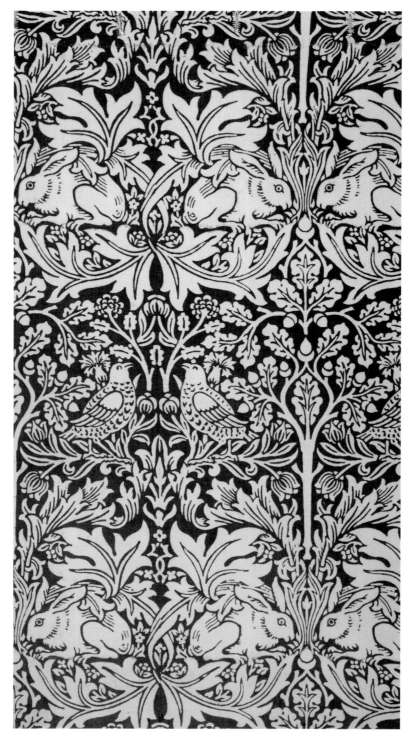

William Morris (1834–96)
Block printed on cotton • Whitworth Art Gallery, Manchester

Brother Rabbit, 1880–81. Morris's design was first registered in 1878. However, he was not satisfied with the indigo printing method used by Thomas Wardle, and did not print it until he moved to Merton.

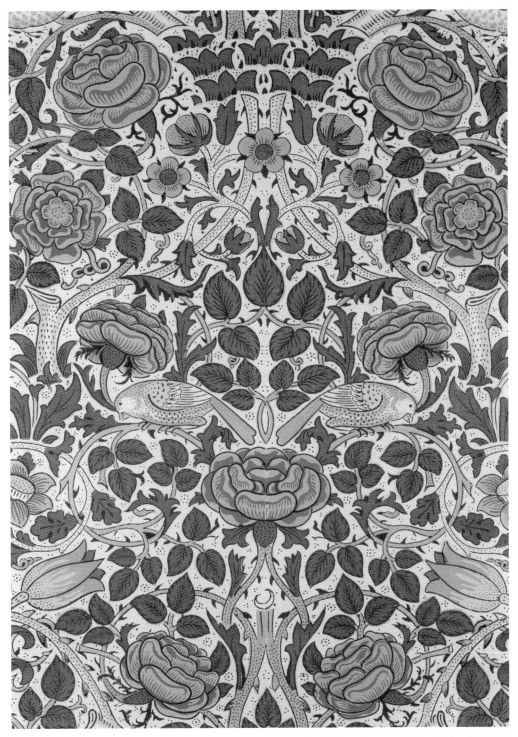

William Morris (1834–96)
Printed cotton • Private Collection

Rose, 1883. Morris had struggled in his early career with the depiction of birds, but writing in 1877 to Thomas Wardle, his dye-maker, that he was making a detailed study of them suggests he had perfected their stylization by the time of this design.

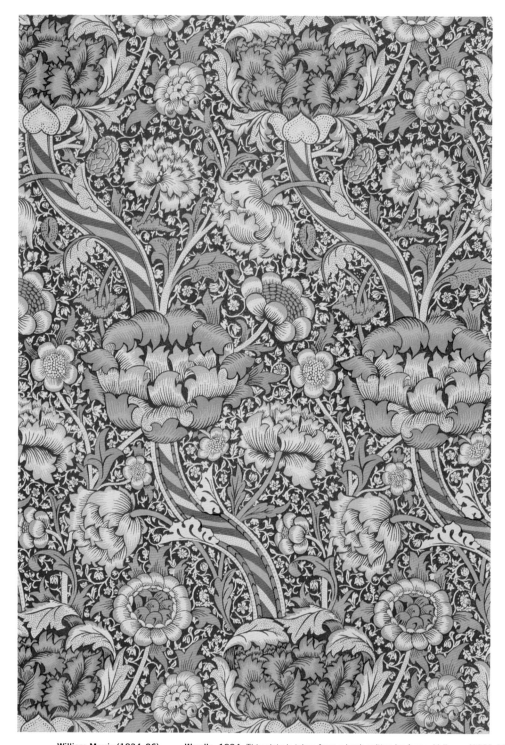

William Morris (1834–96)

Plate from the book *The Art of William Morris* (1897)

• Calmann and King, London

Wandle, 1884. This plate is taken from a book written by Aymer Vallance (1862–1943) about William Morris shortly after his death. *Wandle* was the name given to one of his printed textiles that was named after English rivers.

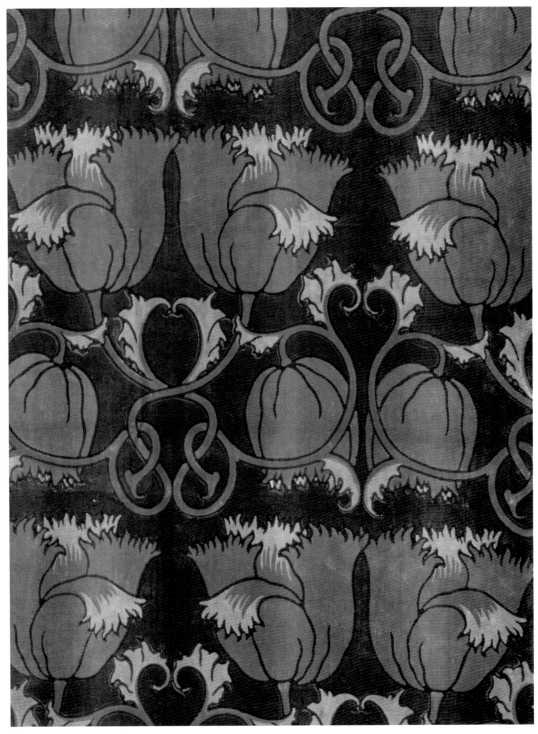

C.F.A. Voysey (1857–1941)
Printed velveteen • Private Collection/The Fine Art Society,
London/Francesca Galloway, London

Poppies, *c.* 1888. These poppies are stylized in order to make a completely symmetrical pattern with a simple repeat. It is printed on velveteen, which does not drape as well as genuine velvet, making it more likely to be used for upholstery rather than curtains.

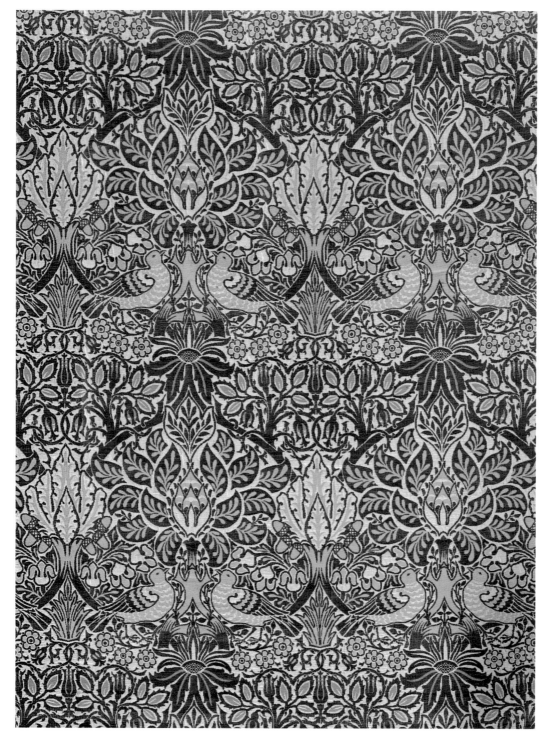

William Morris (1834–96)
Woven silk and wool • Art Gallery of South Australia, Adelaide

Dove and Rose curtain, *c.* 1890. There are a number of variations on this design in terms of colouring and motif size. On this scale it was impractical as an upholstery fabric and was really only used in curtain making.

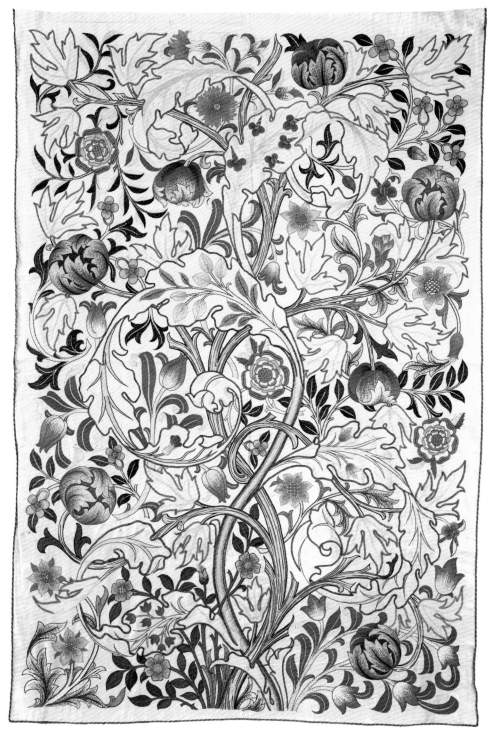

John Henry Dearle (1860–1932)
Silk embroidery on linen • Art Gallery of South Australia, Adelaide

Acanthus portière, *c.* 1890. Portières were popular in Victorian homes of the wealthy. Originally they were intended as an ornate door curtain, particularly in stately homes and castles, to prevent draughts, and may well have been used for the same purpose in larger homes.

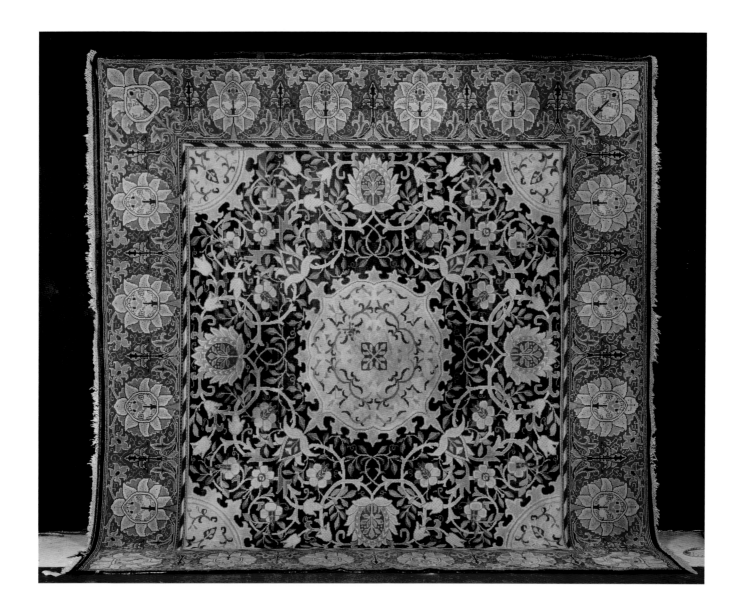

Morris & Co.
Wool • Private Collection

Swan House, 'Hammersmith' hand-knotted carpet, *c.* 1890. Although it bears the name of a 'Hammersmith' carpet, which suggests it was woven at Kelmscott House in London, in fact this carpet was made at Merton Abbey under the direction of John Henry Dearle.

Silver Studio

Watercolour on paper • Middlesex University, London

Textile design, *c.* 1890. The Silver Studio was formed at the height of the popularity of the Arts and Crafts Movement in 1880, and continued well into the middle of the twentieth century, with designs for Liberty & Co and Arthur Sanderson & Sons Ltd.

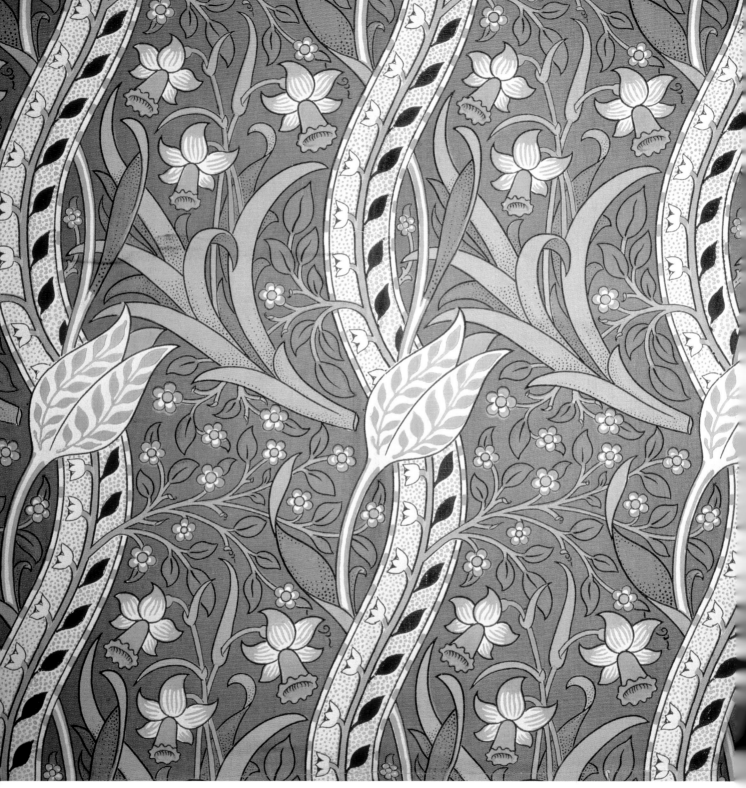

John Henry Dearle (1860–1932)
Printed cotton • Private Collection

Daffodil, 1891. This design is known as 'chintz', a seventeenth-century Dutch import from India utilizing a floral motif such as this. Dearle's use of chintz is in line with his own departure from more conventional Morris & Co patterns.

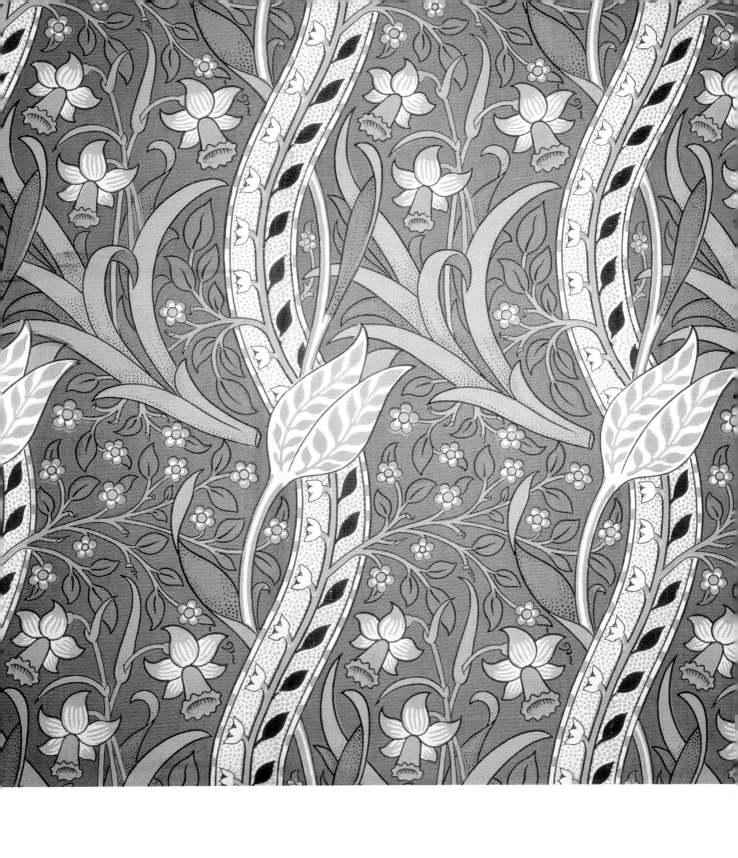

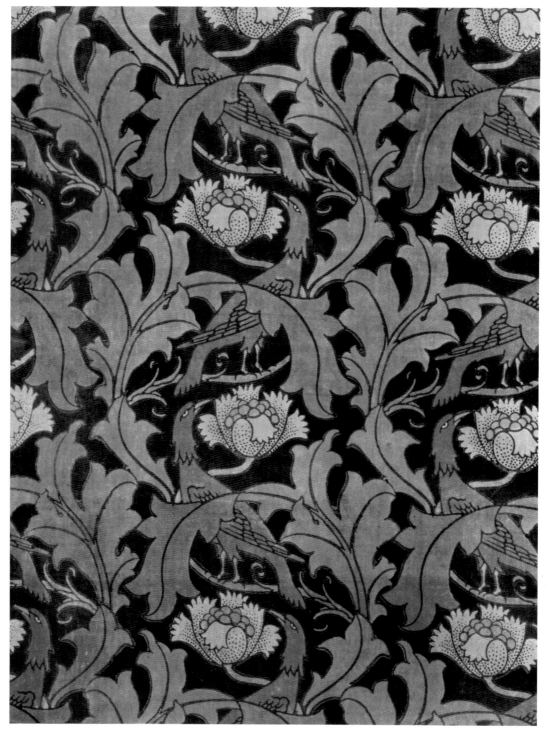

C.F.A. Voysey (1857–1941)
Printed velveteen • Private Collection

Flowers and Leaves with Birds, *c.* 1893. GP and J Baker, a firm that was founded in 1884 and still produces high quality fabrics today, printed this pattern for Liberty & Co. The firm currently holds a warrant to supply some of the royal households.

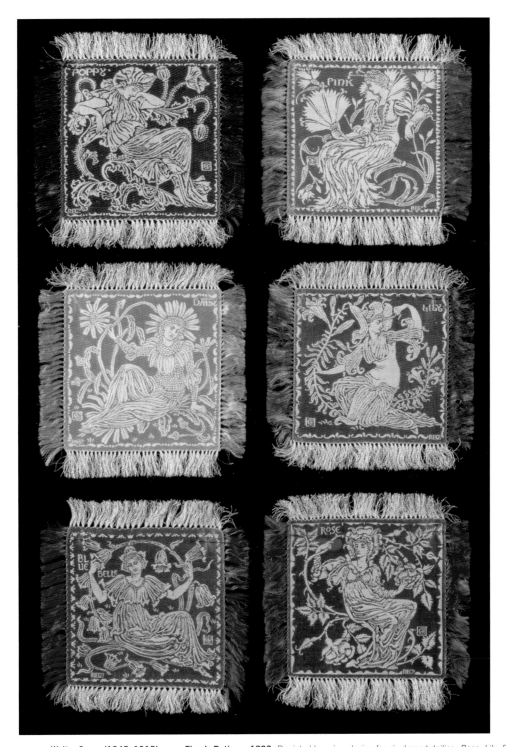

Walter Crane (1845–1915)
Silk damask • Private Collection/The Fine Art Society,
London/Francesca Galloway, London

Flora's Retinue, 1893. Depicted here is a design for six dessert doilies, *Rose, Lily, Daisy, Poppy, Pink* and *Bluebell*, all made in silk damask. Most doilies were made in linen, suggesting that this design was for a wealthy client.

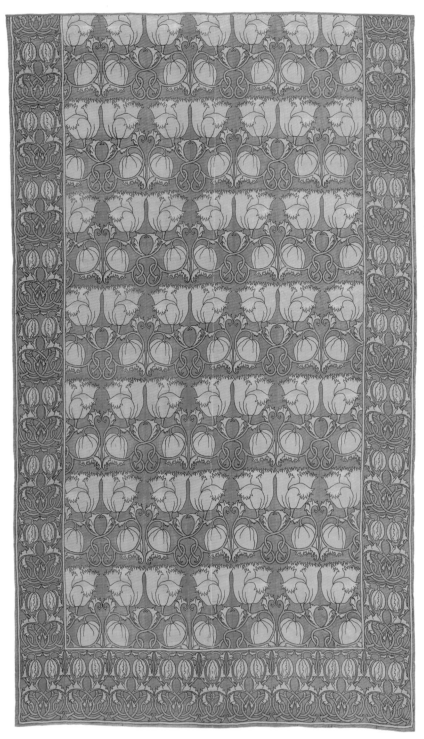

C.F.A. Voysey (1857–1941)
Silk plain weave, block printed • Museum of Fine Arts, Boston

Bed cover, *c.* 1895. This expensive bed cover was designed by Voysey and printed by GP and J Baker on silk, possibly for retail by Liberty & Co. The pattern is symmetrical and uses a stylized floral motif with a contrasting border.

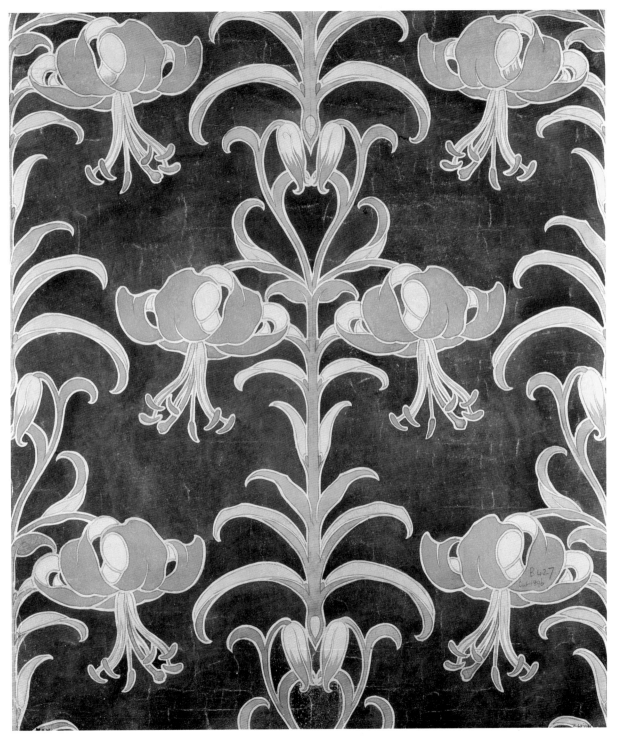

Lindsay P. Butterfield (1869–1948)
Watercolour on paper • Victoria and Albert Museum, London

Tiger Lily, 1896. Butterfield was one of the most successful freelance designers at the turn of the century, producing designs for Liberty & Co and the Silver Studio. This design was sold to GP and J Baker.

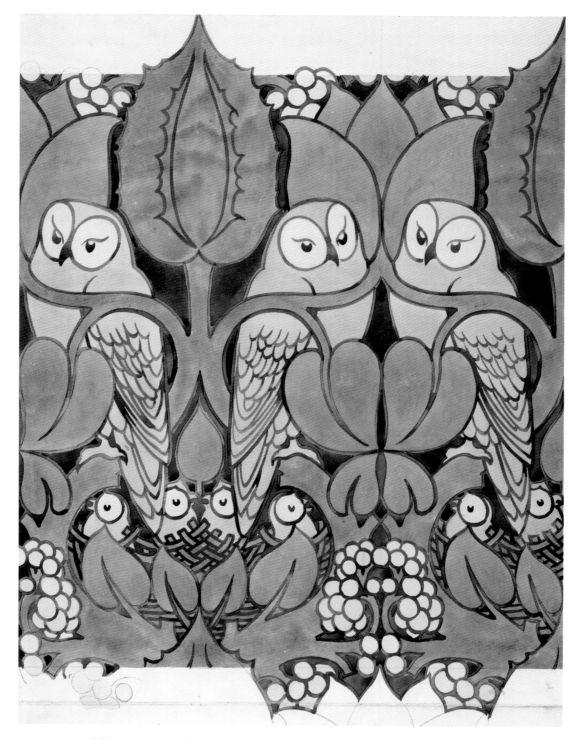

C.F.A. Voysey (1857–1941)
Watercolour and pencil on paper • Victoria and Albert Museum, London

Owls, 1897. Voysey originally intended this design to be used as wallpaper but Alexander Morton & Co adapted it as a woven textile design for curtains and upholstery use.

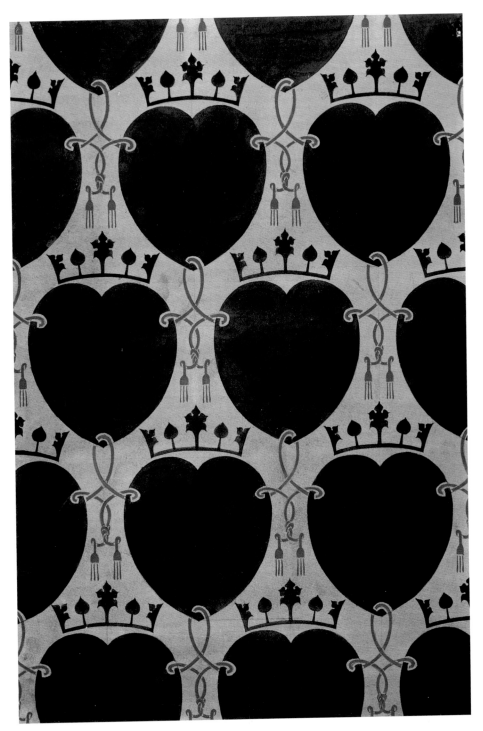

C.F.A. Voysey (1857–1941)
Watercolour on paper • Royal Institute of British Architects, London

Design for a fabric, *c.* 1898. Apart from flora and fauna, Voysey's favourite motif was the heart, which he incorporated into furniture as well as fabrics and wallpaper. This design also includes a coronet, which lends a very regal feel.

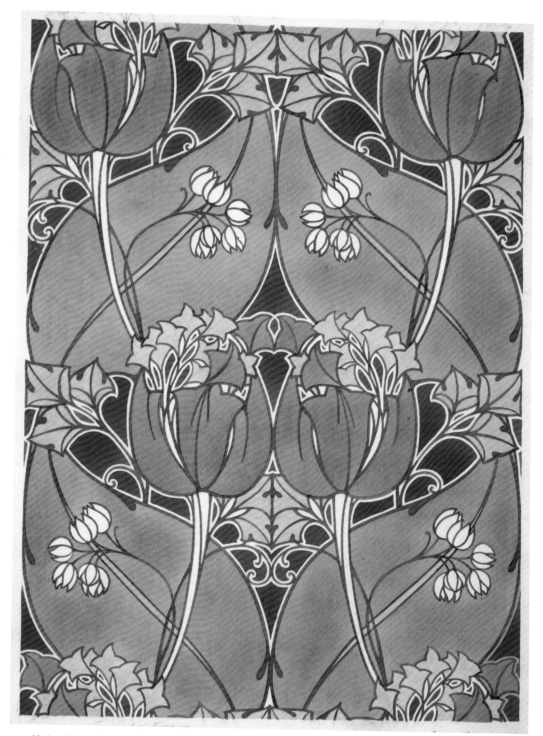

Lindsay P. Butterfield (1869–1948)
Watercolour on paper • Victoria and Albert Museum, London

Design for a floral woven textile, 1905. While studying at the National Art Training School, Butterfield won the Owen Jones prize in a national competition. Its relevance can be seen in this design which follows Jones's theories about the development of modern pattern making.

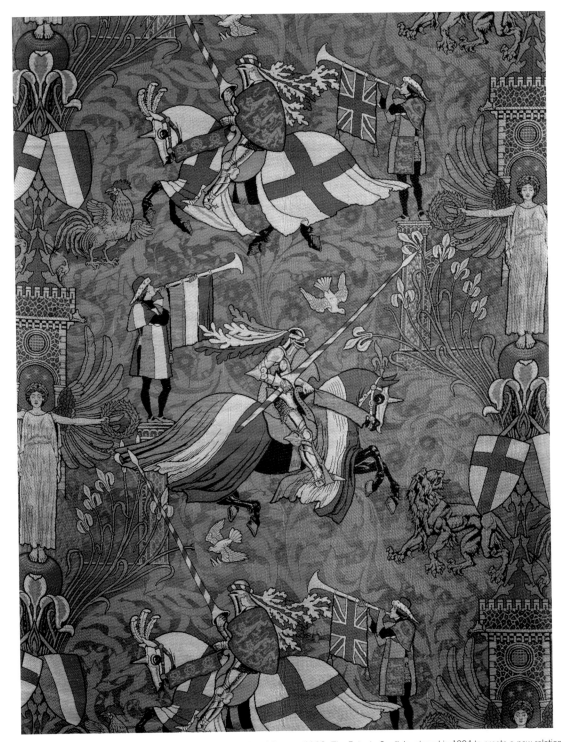

Walter Crane (1845–1915)

Woven wool and cotton fabric • Whitworth Art Gallery, Manchester

England and France, 1908. The Entente Cordiale, signed in 1904 to create a new relationship and alliance between France and the United Kingdom, may well have inspired Crane's design. It incorporates elements of both cultures: St George and the *fleur-de-lys*.

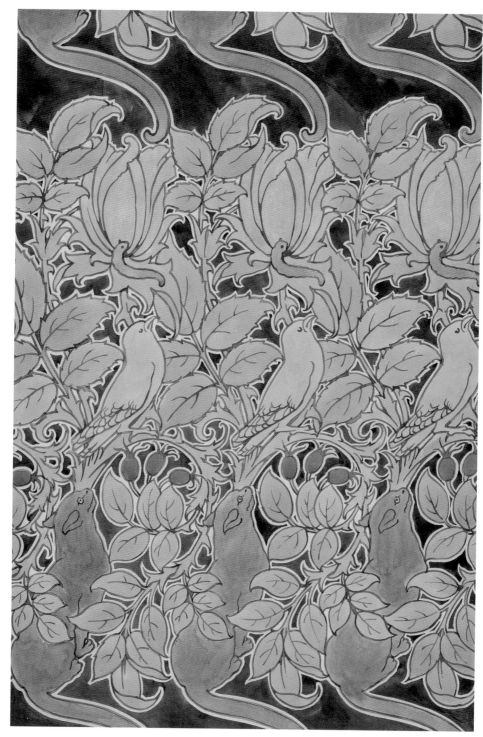

C.F.A. Voysey (1857–1941)
Watercolour and pencil on paper • Victoria and Albert Museum, London

Let us Prey, 1909. Voysey adopted a witty pun in this design that demonstrated the food chain and included one of his favourite motifs, the bird, and its potential meal of a worm.

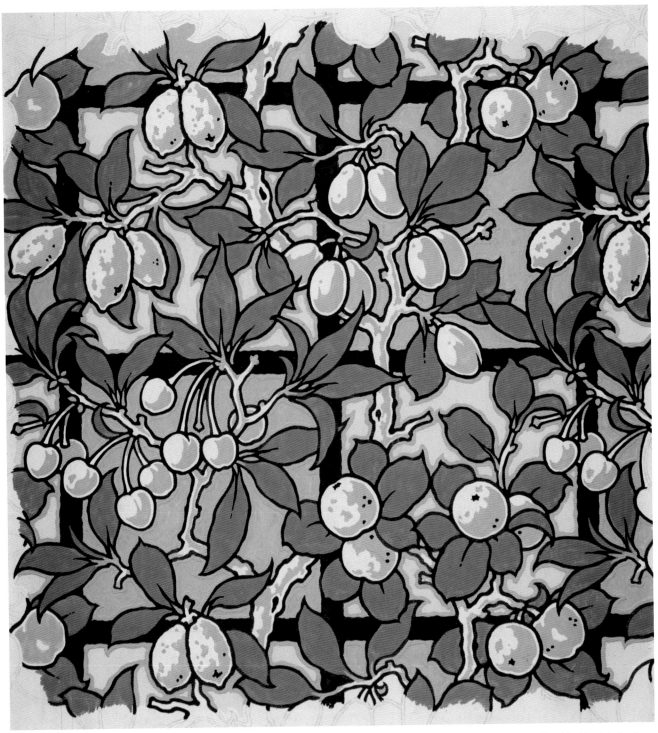

Lindsay P. Butterfield (1869–1948)
Watercolour on paper • Calmann and King, London

Mixed Fruit on Trellis, 1910. The use of a trellis is borrowed, of course, from Morris's original wallpaper pattern, but in this design Butterfield moves away from the natural elements to a more stylized and modern motif without the use of fauna.

Ceramics

Nothing captures the spirit
of the Arts and Crafts Movement
in quite the same way as ceramics,
from the various forms of decorative
tile-making to art pottery, since the
design process and the manufacture
are often undertaken by the
same craftsman.

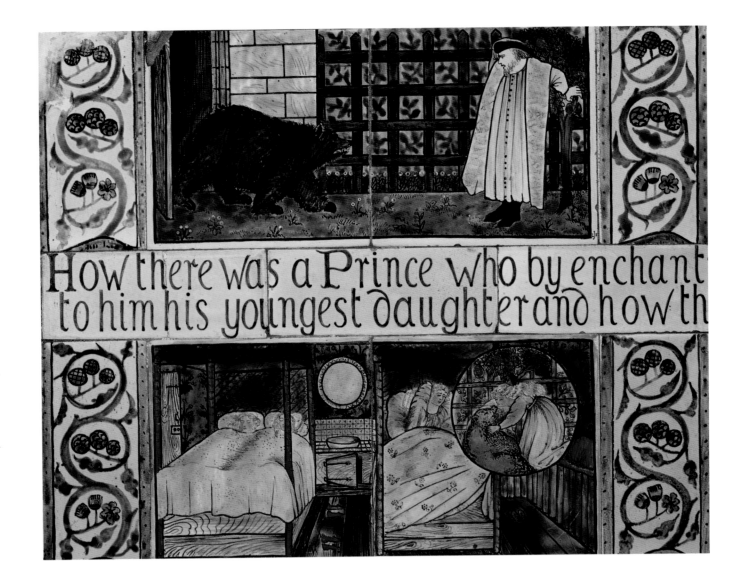

Edward Burne-Jones (1833–98)
Ceramic tiles • Private Collection

Beauty and the Beast, *c.* 1867. This is a set of eight ceramic tiles with a decorative tile border depicting the fairy story. It was designed by Burne-Jones and hand-painted by Kate Faulkner (*fl.* 1868–75), who was working for Morris & Co at the time.

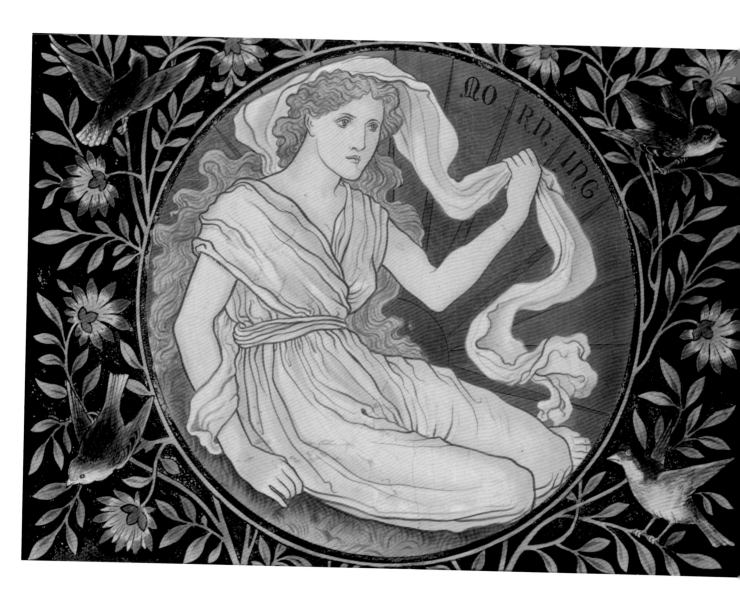

Shrigley and Hunt
Ceramic • Private Collection

Morning, 1876. Shrigley and Hunt was a manufacturer of stained-glass windows and art tiles based in Lancaster. The image depicted here of an allegorical figure representing the rising sun, is lifted straight from designs and paintings by the Pre-Raphaelite artist Dante Gabriel Rossetti.

Edward W. Godwin (1833–86)
Ceramic with overglaze and gilded decoration
on underglaze transfer design • Private Collection

Gemini and Cancer, *c.* **1876.** Godwin was an Arts and Crafts designer who moved effortlessly from Gothic Revival to Aestheticism, most notably in his design for a house to be occupied by the artist James McNeill Whistler, in London's Tite Street in Chelsea.

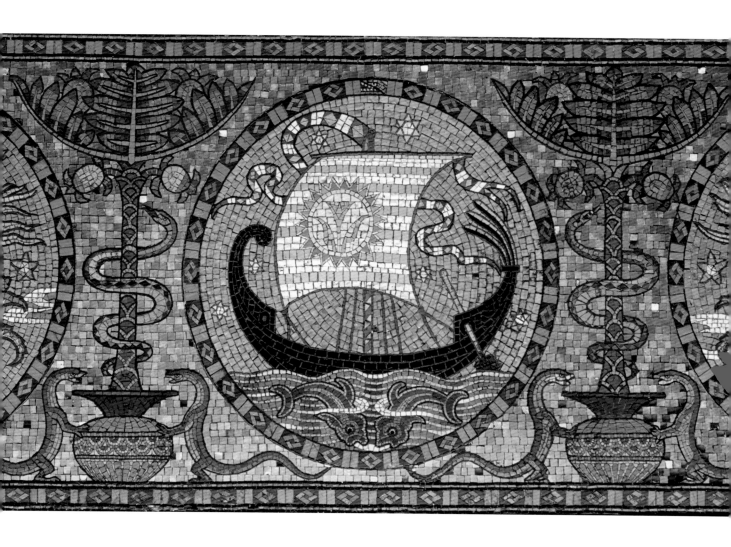

Walter Crane (1845–1915)
Mosaic • Leighton House, London

Detail of the Gold Mosaic Floor, *c.* 1881. This was part of the opulent decorative scheme for the interior of Leighton House, the home of the artist Frederic, Lord Leighton. The mosaic work is by the Italian firm Salviati & Co, who also executed designs at St Paul's Cathedral in London.

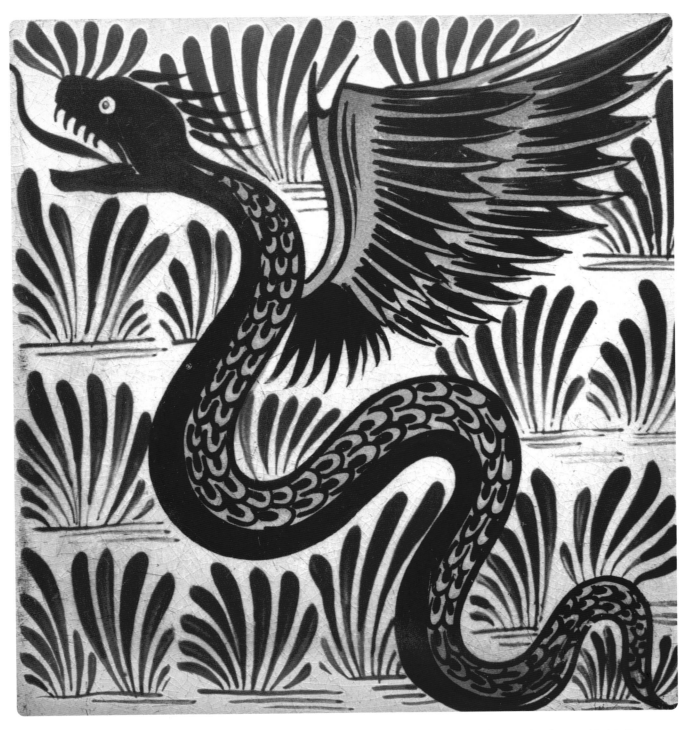

William De Morgan (1839–1917)
Ceramic • The De Morgan Centre, London

Red Dragon, late nineteenth century. The De Morgan figures, such as the serpent depicted here with wings, were referred to as 'fantastical'. These strange looking animals and grotesques were popular in the nineteenth century, particularly in children's illustrated books.

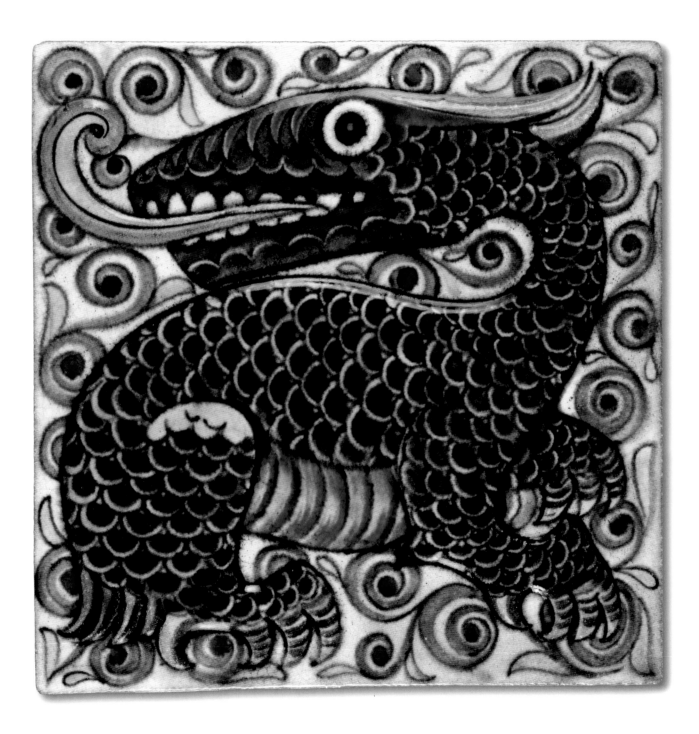

William De Morgan (1839–1917)
Ceramic • Fitzwilliam Museum, Cambridge

Buff earthenware tile, *c.* 1882–86. The wonderful iridescent colours of the dragon's body are well suited to the style of tile-making perfected by De Morgan, based on the Iznik pottery he would have seen at the British Museum.

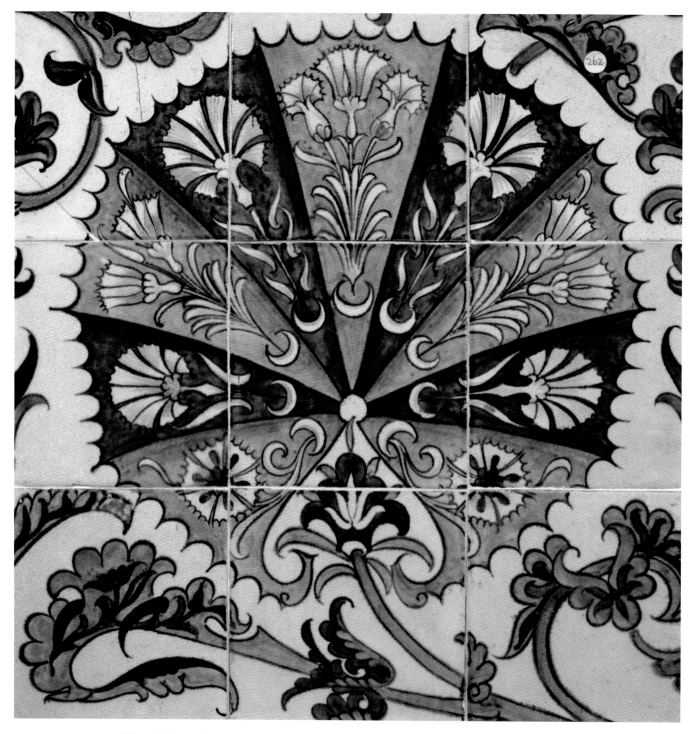

William De Morgan (1839–1917)
Ceramic • The De Morgan Centre, London

Tile panel with floral design, late nineteenth century. Many of De Morgan's designs were intended as panels using a group of tiles to make an entire picture. In this case the image is revealed as a pure pattern with a central focus clearly influenced by Owen Jones.

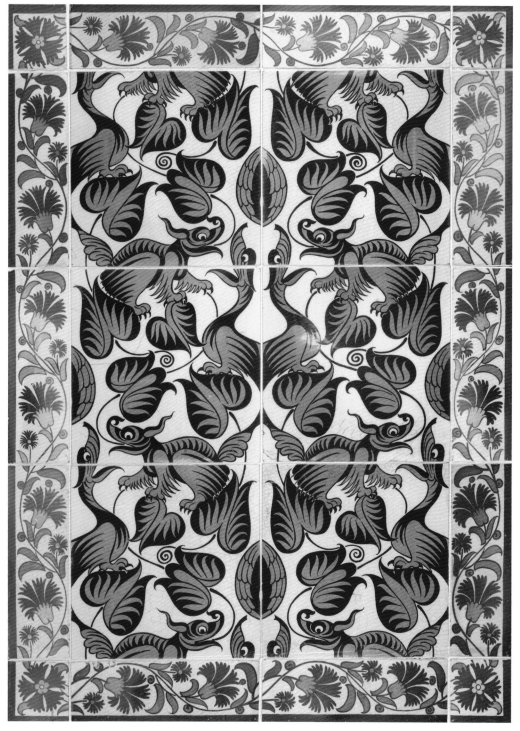

William De Morgan (1839–1917)
Ceramic • Fitzwilliam Museum, Cambridge

Dragons and Foliage, *c.* 1882. This panel consists of 20 tiles with a slip-coat glaze and painted in a red lustre. The central feature is a series of dragon and bird grotesques, tempered by a border that depicts flowers and leaves.

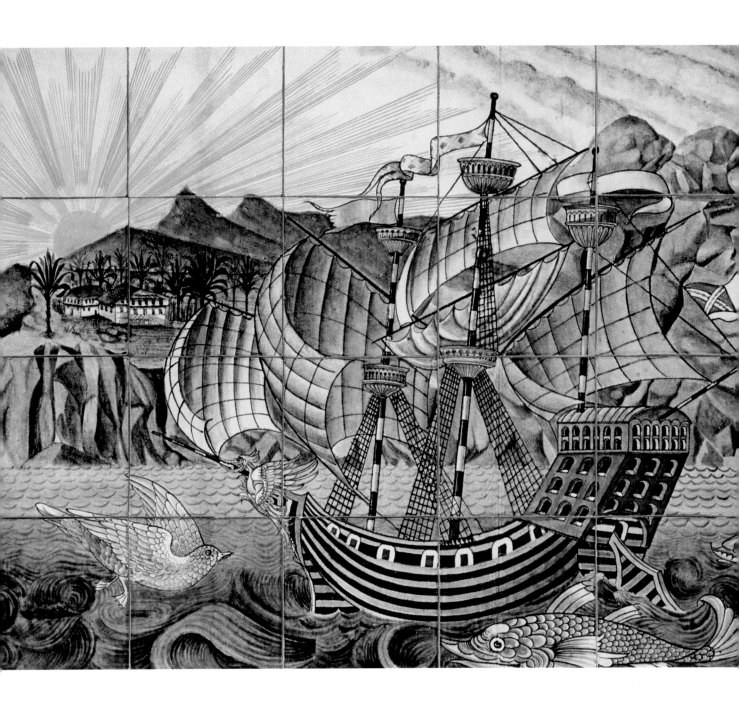

William De Morgan (1839–1917)
Ceramic • The De Morgan Centre, London

Tile panel depicting galleons, 1888–97. De Morgan frequently used the galleon motif. The P&O Steamship Company commissioned this tile panel for use on their new ship *SS Malta*. He was commissioned to create 12 of these schemes between 1882 and 1900.

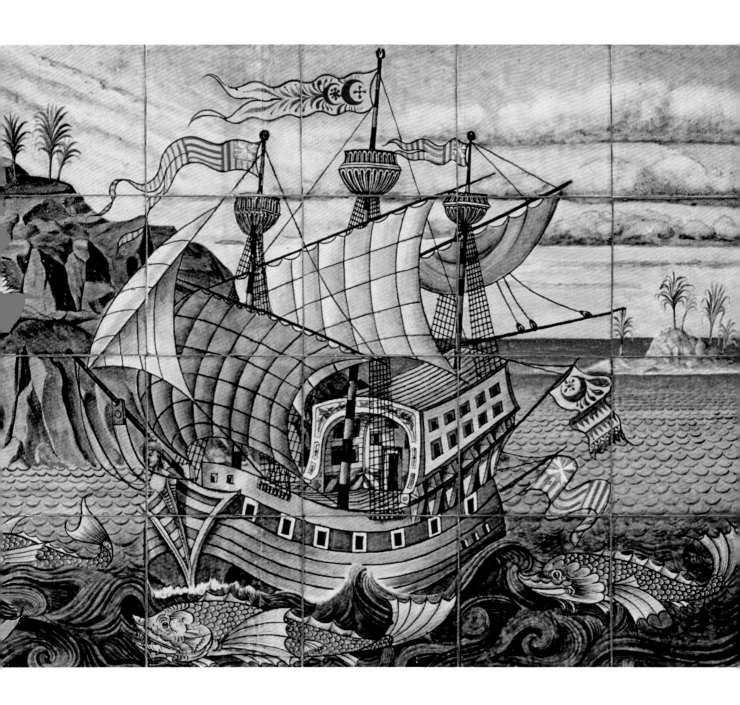

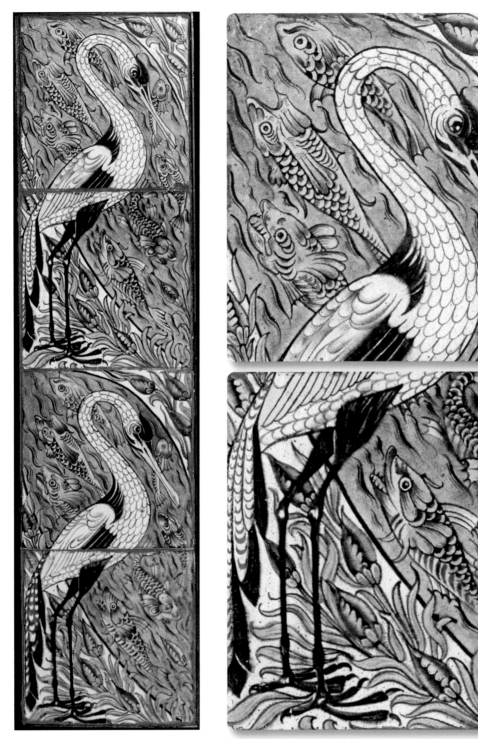

William De Morgan (1839–1917)
Ceramic tiles • The De Morgan Centre, London

Four tiles depicting fishing birds, late nineteenth century. De Morgan takes a more naturalistic approach to the depiction of these herons but in an unusual vertical format. It is, however, a repeating pattern and could be utilized in a number of different ways.

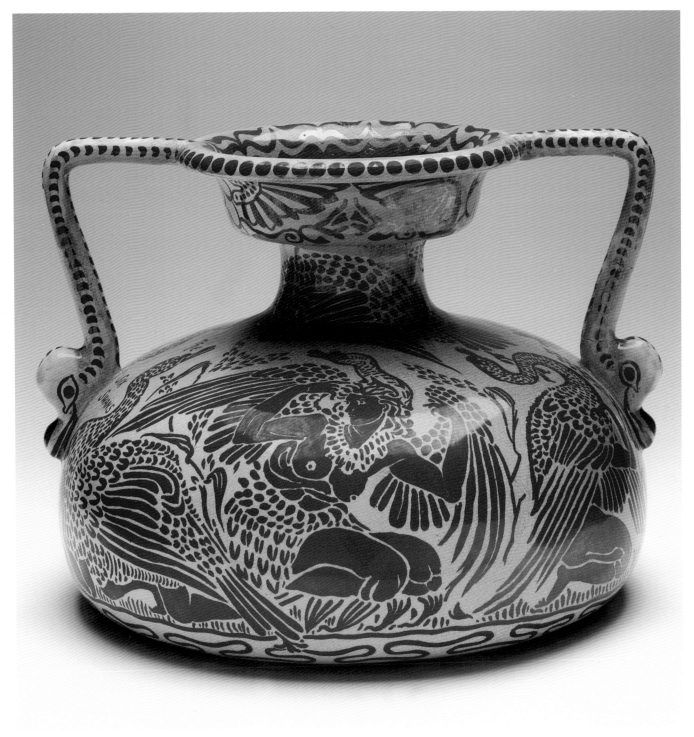

Walter Crane (1845–1915)
Ceramic pottery • Musée Ariana, Geneva

Vase with handles, 1890. Given its lack of height, this object was almost certainly intended as a display piece. The red figures are inspired by Eastern art and it would probably have been displayed on an ebony sideboard, in the Aesthetic style.

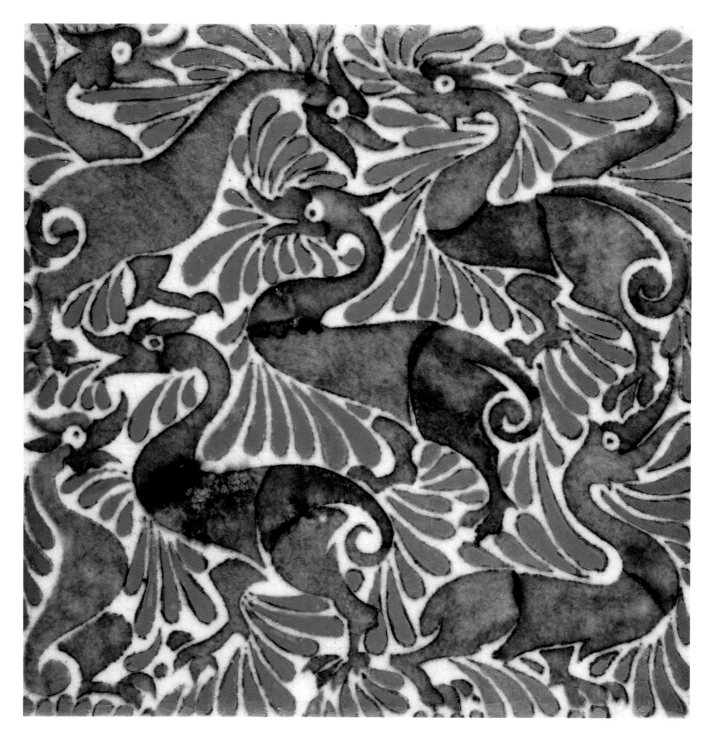

William De Morgan (1839–1917)
Earthenware with lustre glaze • Fitzwilliam Museum, Cambridge

Tile with dark blue bird-like dragons among foliage, 1898. At the time of making this tile, De Morgan had moved from his factory at Merton (next door to William Morris) to Fulham, in partnership with the architect Halsey Ricardo (1854–1928), where he perfected many of his glazing techniques.

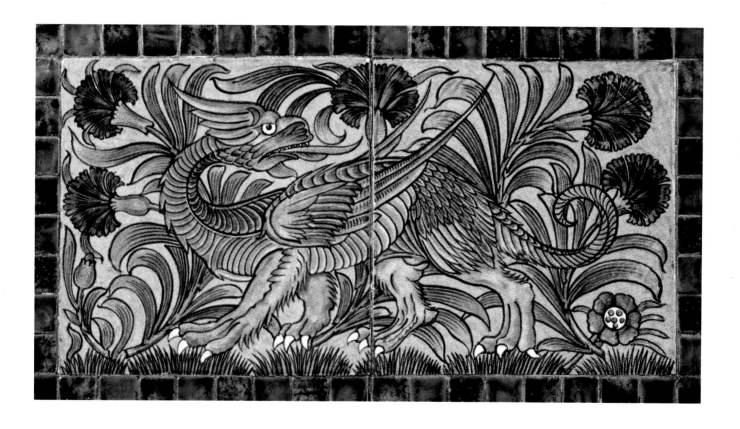

William De Morgan (1839–1917)
Ceramic • The De Morgan Centre, London

Tile with dragon design, late nineteenth century. Both William and his wife, Evelyn (1855–1919), were very spiritual people. Dragons appear as a motif in Evelyn's paintings and William's ceramics as a symbol of sin. In this image the dragon is juxtaposed with carnations, a symbol of love.

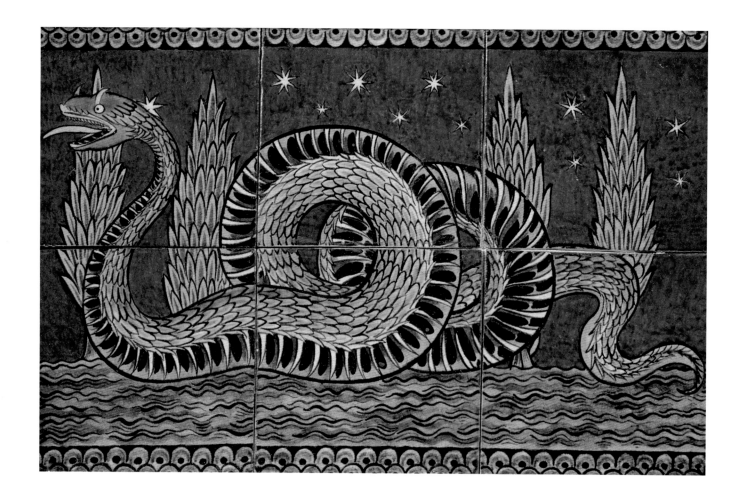

William De Morgan (1839–1917)
Ceramic • The De Morgan Centre, London

Mythical beast tile panel, late nineteenth century. The colours used and the style of this panel are influenced by Persian design in which De Morgan was particularly interested. His wife, Evelyn, was a Pre-Raphaelite artist and also used mythical subjects in her paintings.

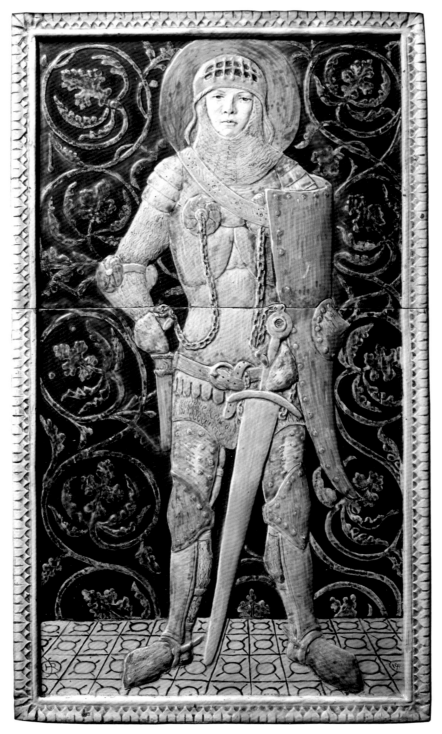

Harold Rathbone (1858–1929)
Ceramic • Delaware Art Museum, Delaware

Gideon, *c.* 1900. Rathbone set up the Della Robbia Pottery factory in 1894, producing 'art pottery'. He had been a student of the Pre-Raphaelite artist Ford Madox Brown, one of the founders of Morris & Co.

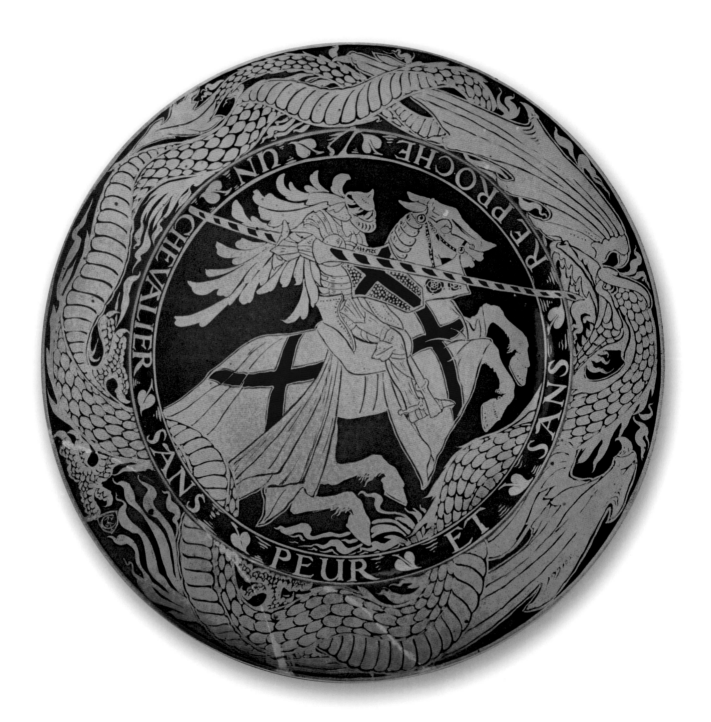

Walter Crane (1845–1915)
Earthenware with blue glaze, with on-glaze painted decoration
in gold lustre with red • Delaware Art Museum, Delaware

England's Emblem, 1907. Crane appears to have mixed his French and English knights in this design. The knight depicted is St George with the red-cross banner slaying the dragon, but the motto is in French and belongs to *Le Chevalier Bayard*.

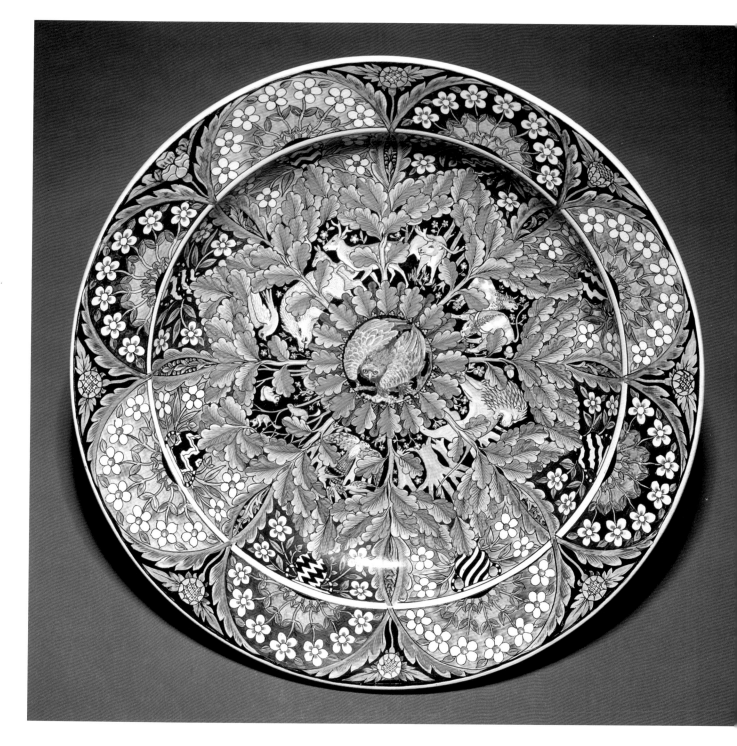

Alfred Powell (1865–1960)
Earthenware painted in enamels • Fitzwilliam Museum, Cambridge

Wedgwood dish, *c.* 1908. Powell and his wife Louise (1882–1956) became famous as pottery designers for Wedgwood at their Etruria factory in Staffordshire. Like many other Arts and Crafts practitioners they settled in the Cotswolds district.

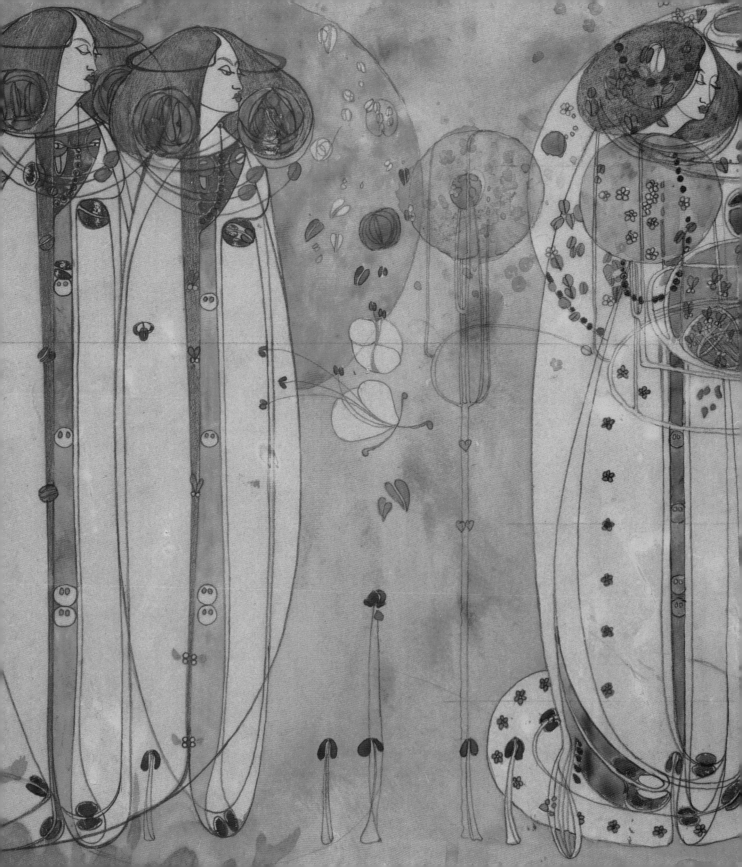

Artworks

This section covers a broader selection of designs for use in schemes and unusual objects such as panels, books and three-dimensional objects. It also gives examples of the work of other practitioners who were design theorists as well as designers.

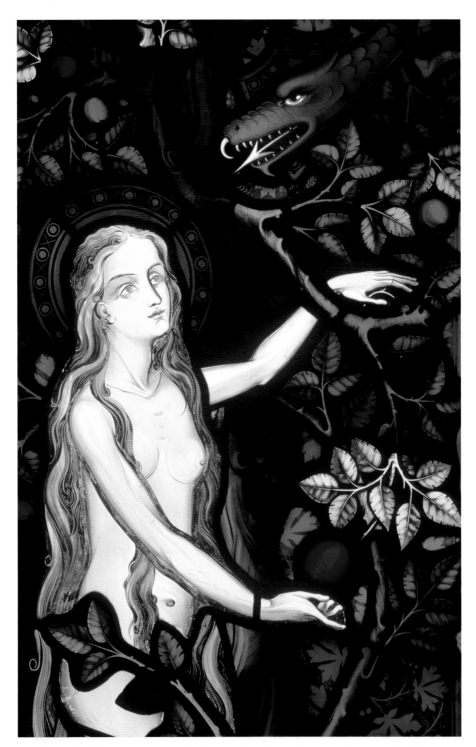

A.W.N. Pugin (1812–52)
Stained glass • The Stained Glass Museum, Ely

Temptation of Eve, 1850. One of a pair of windows originally designed for a church in Norfolk, this image appears to depict Eve not as a *femme fatale* but rather as a naïve victim, emphasized by the suggestion of a halo around her head.

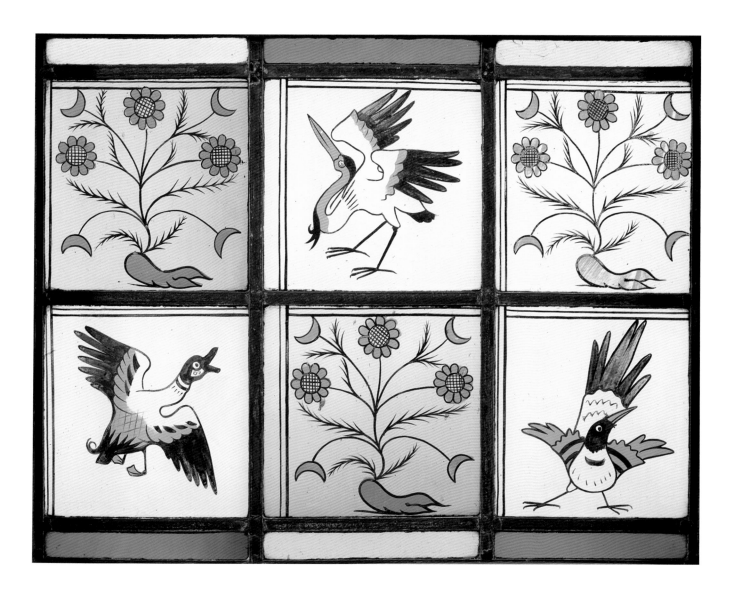

Philip Webb (1831–1915)
Stained glass • Private Collection

Window depicting birds and flowers, *c.* 1860. The stylized depictions of a duck, magpie and heron were repeated in a larger series of ceramic tiles of birds between 1860 and 1870. The use of stained glass in homes was popular at this time.

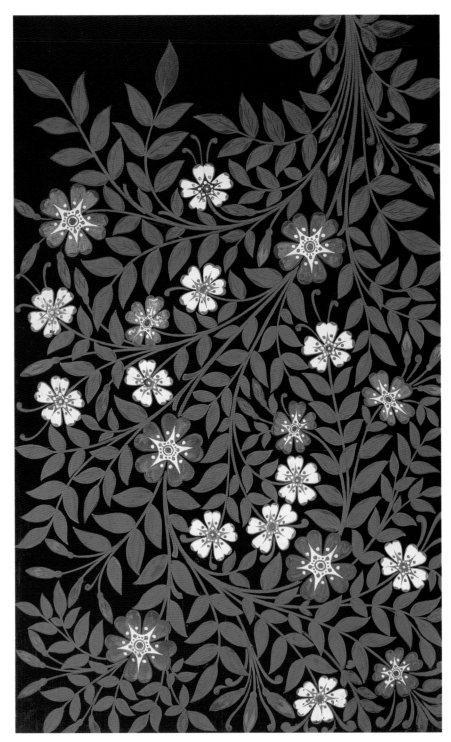

Owen Jones (1809–74)
Colour lithograph • Private Collection

Floral design, 1863. Jones sought a modern style of design fit for the nineteenth century that was devoid of the historicism prevalent in the mid-nineteenth century. This design gives no illusion of depth and emphasizes its 'flatness' on the picture surface.

Christopher Dresser (1834–1904)
Lithograph • Private Collection

Plate One from Studies in Design, *c.* **1874–76.** A protégé of the design theorist Owen Jones, Dresser published several books on design himself, including *Studies in Design*, published in 1876 and comprising 60 colour plates in chromolithography.

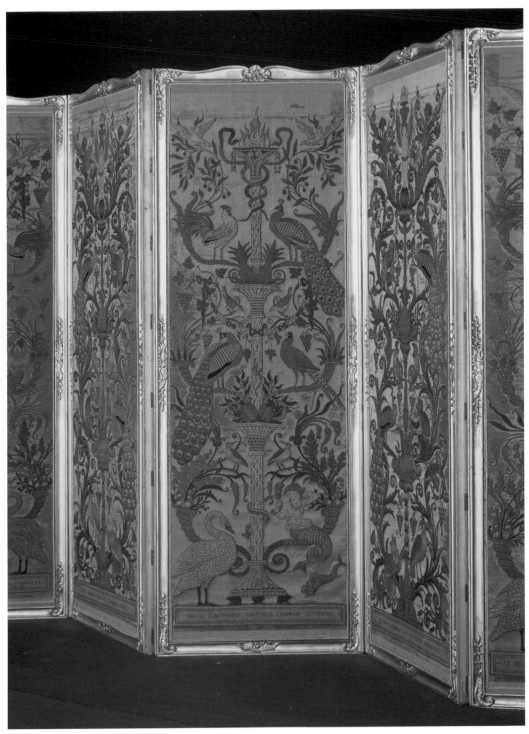

Walter Crane (1845–1915)
Embroidered panels • Victoria and Albert Museum, London

Screen, 1876. This elaborate panel was made specifically as an exhibition piece depicting the four elements of earth, fire, air and water. This was probably shown as part of the School of Art Needlework exhibit in Philadelphia in 1876.

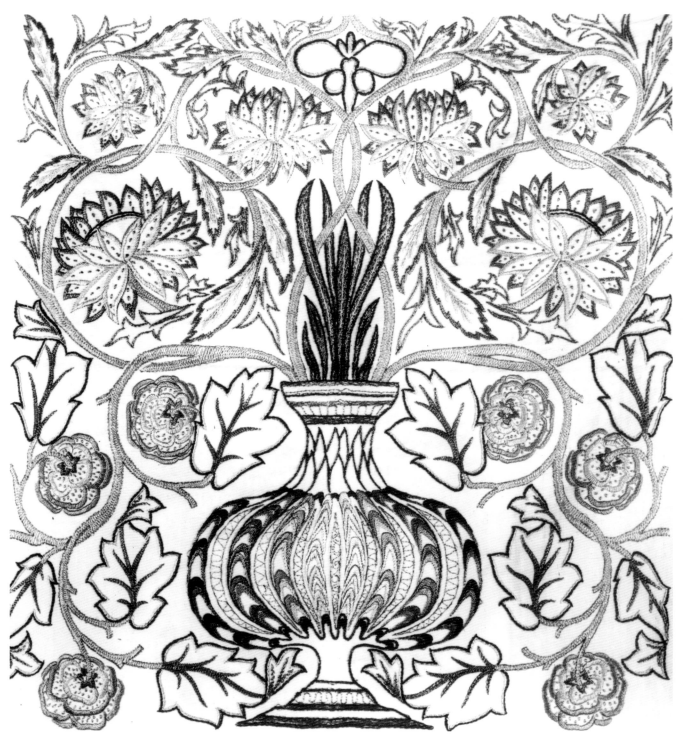

William (1834–96) and May Morris (1862–1938)
Embroidered panel • William Morris Gallery, London

The Flower Pot, 1878–80. This Morris design could be purchased from Morris & Co either as a completed tapestry or as a kit. It came in different sizes so that it could be used, for example, either as a cushion cover or a fire screen.

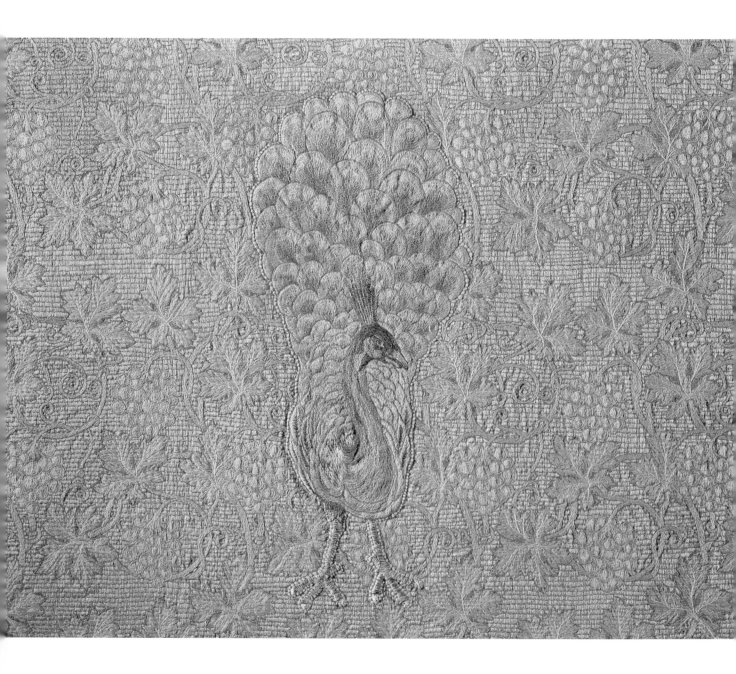

William Morris (1834–96) and Philip Webb (1831–1915)
Wool on linen • Private Collection

Peacock and Vine, secular form of altar frontal, *c.* **1880–1900.** Although this was designed for secular use, the peacock was used in early Christianity as a symbol of immortality, and the 'eyes' in the tail feathers are supposed to represent the 'all-seeing' God.

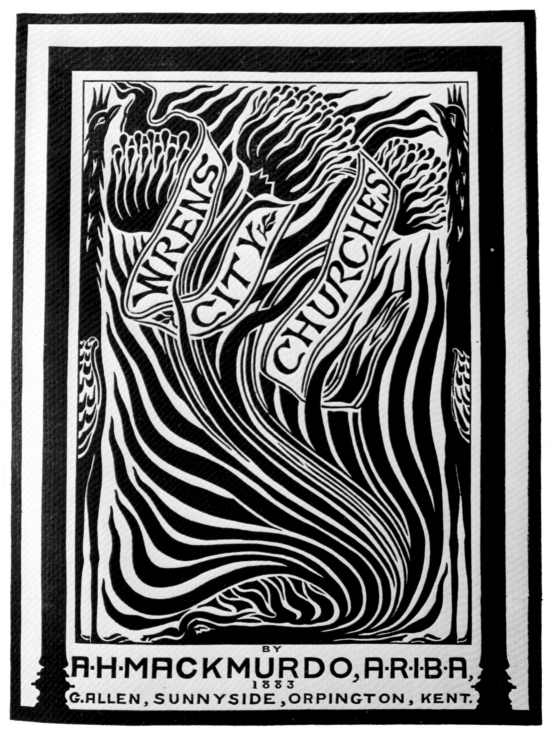

Arthur Mackmurdo (1851–1942)
Printed paper • Victoria and Albert Museum, London

Wren's City Churches, title page, 1883. Design historians have used this image frequently to demonstrate how the British designer Arthur Mackmurdo anticipated the Continental Art Nouveau style that did not flourish until at least 1895.

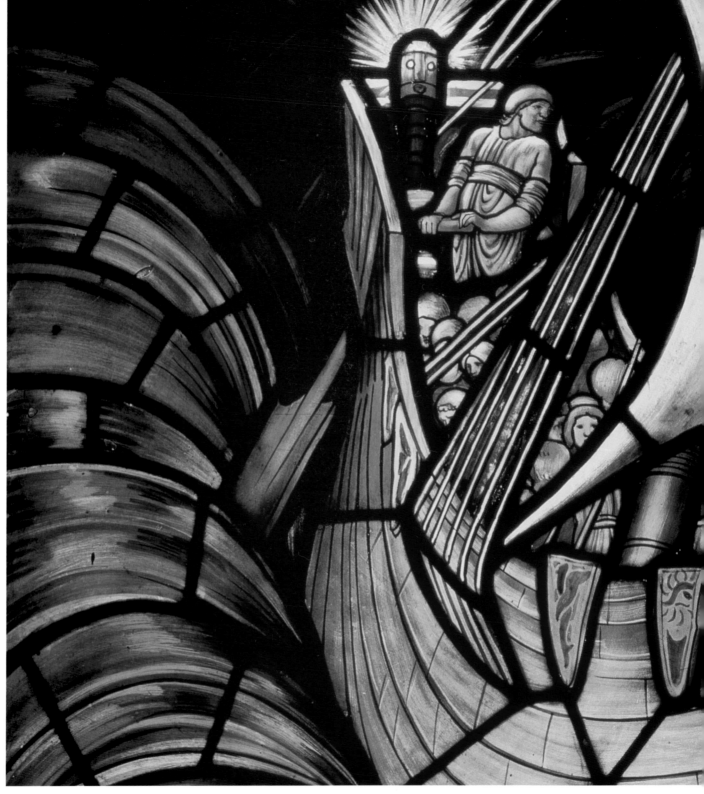

Edward Burne-Jones (1833–98)
Stained glass • Delaware Art Museum, Delaware

Viking Ship, c. 1884–85. This unusual design was created as part of a large decorative scheme for the home of a wealthy American art collector and patron, Catherine Wolfe, at Newport, Rhode Island.

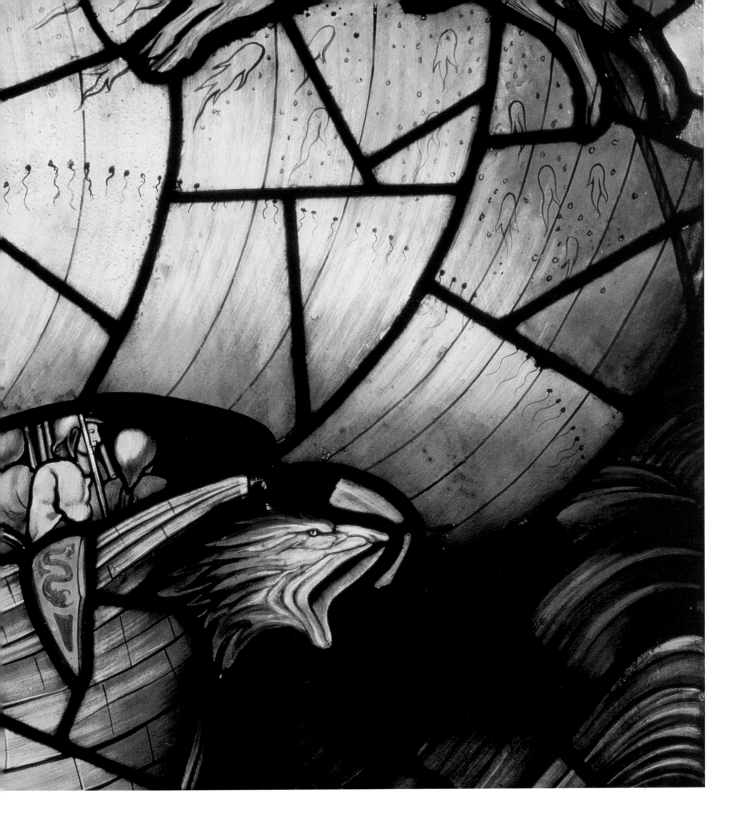

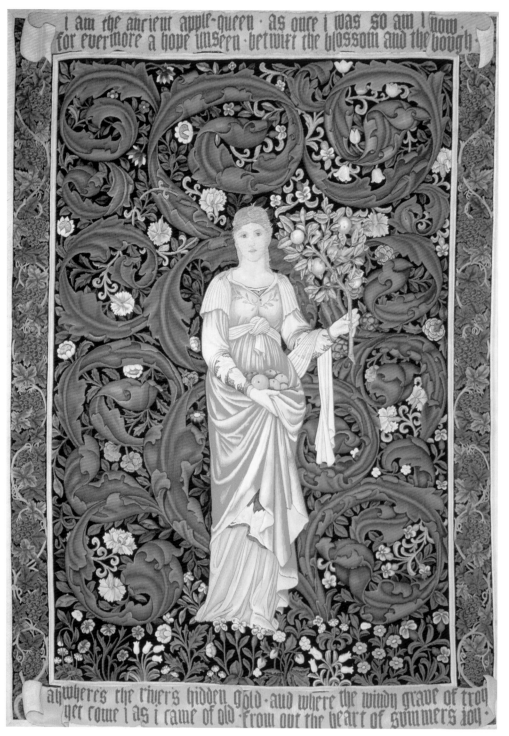

I am the ancient apple-queen · as once I was so am I now.
for evermore a hope unseen · betwixt the blossom and the bough

ah where's the river's hidden gold · and where the windy grave of troy
yet come I as I came of old · from out the heart of summers joy

Edward Burne-Jones (1833–98) for Morris & Co
Wool and silk tapestry • Whitworth Art Gallery, Manchester

Pomona, 1884–85. The central figure in this design is notably by Burne-Jones but the background is equally typical of William Morris, or possibly his chief designer John Henry Dearle. There is a later version of this design in which Dearle is given credit.

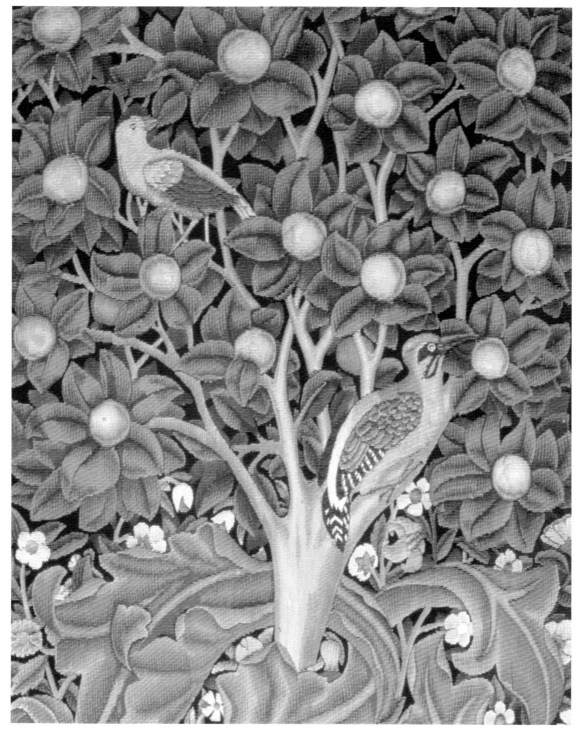

William Morris (1834–96)
Wool on cotton lining • Private Collection

The Woodpecker tapestry, 1885. This is the upper detail of a much longer vertical tapestry. William Morris wove it with his daughter May, at Merton Abbey. At the top and bottom of the work is a short poem by William Morris.

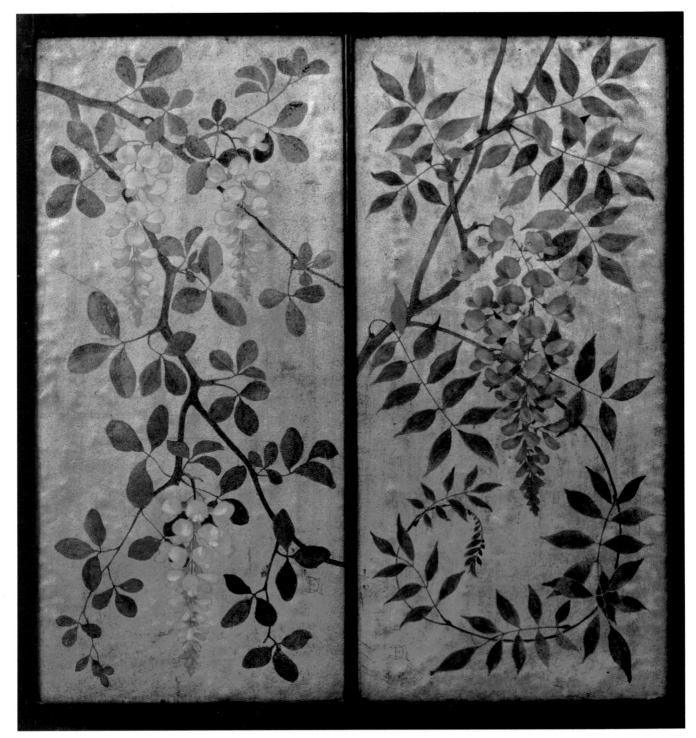

Lewis F. Day (1845–1910)
Painted leather • The Fine Art Society, London

Wisteria, decorative panel, *c.* **1890.** These types of decorative panels were used as wall hangings in place of more traditional paintings. The wisteria motif is probably taken from its use in Japanese art, which was very popular at the time.

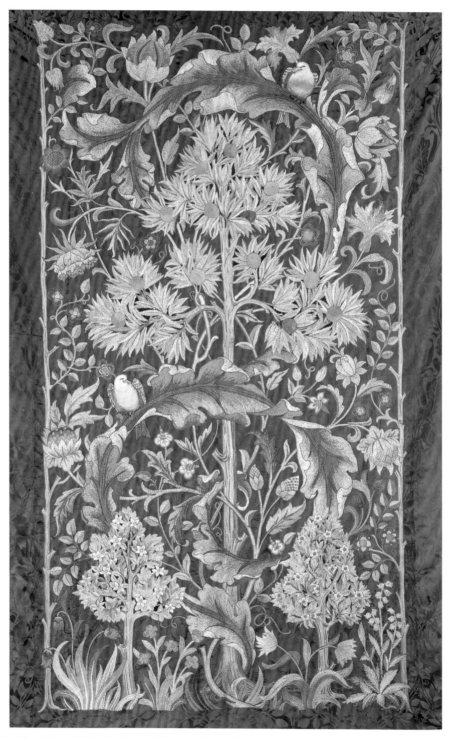

John Henry Dearle (1860–1932)
Embroidery on silk • Victoria and Albert Museum, London

Pigeon portière, *c.* 1890. This design was intended to be used as part of a kit for the more advanced amateur embroiderer, having been purchased at the showrooms of Morris & Co, complete with embroidery silks.

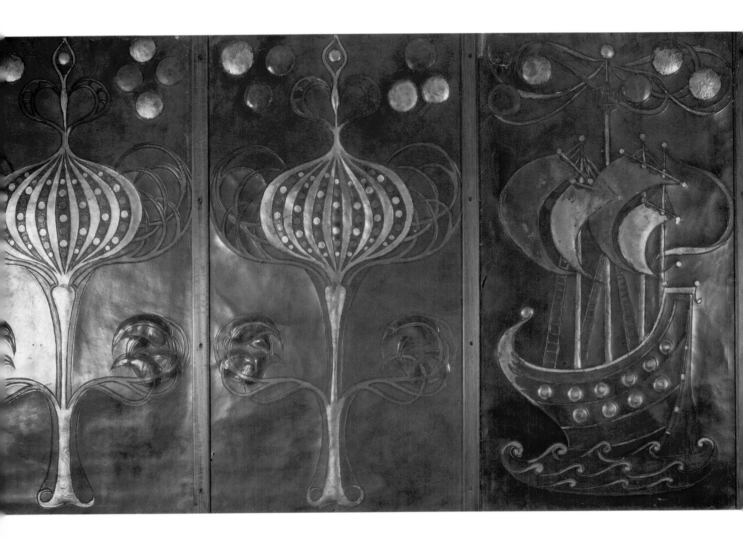

The Guild of Handicrafts
Embossed, painted and gilded on leather
• Cheltenham Art Gallery & Museum, Cheltenham

Decorative panels, 1892. Although the actual designer of this was C.R. Ashbee, at the time of its creation it would have been sold as coming from the workshops of the Guild of Handicrafts to demonstrate its branding.

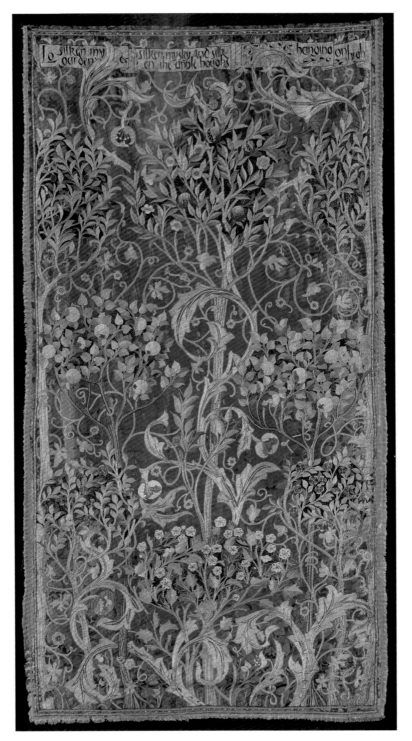

May Morris (1862–1938)
Silk embroidery on silk 'oak' damask
• Museum of Fine Arts, Boston

Portière, 1892–93. This is one of four designs for portières commissioned by Mary Beecher Longyear, a wealthy American philanthropist, for her home in Michigan. William Morris designed the green 'oak' damask fabric in 1880, for Morris and Co.

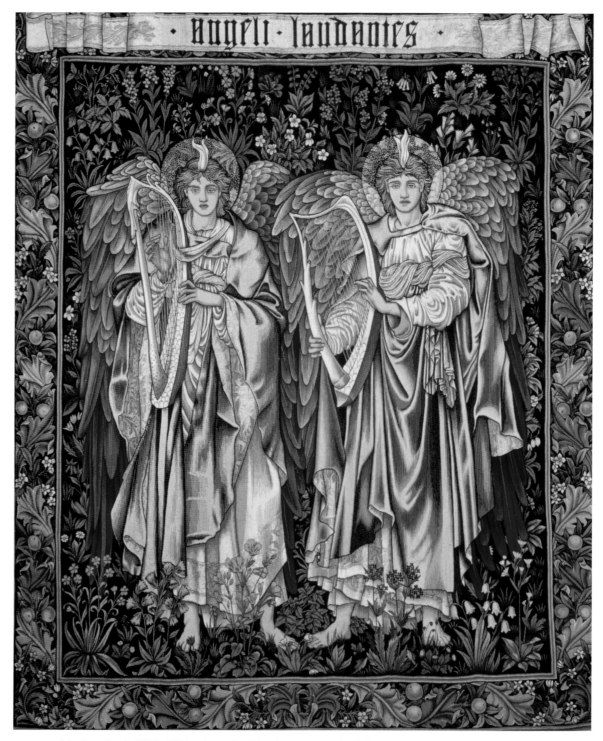

**John Henry Dearle (1860–1932) and
Edward Burne-Jones (1833–98)**

Wool and silk on cotton • Victoria and Albert Museum, London

Angeli Laudantes tapestry, 1894. This design is taken from a stained-glass window created by Burne-Jones in 1877 for Salisbury Cathedral. It is one of a pair of tapestries adapted from the design by Dearle.

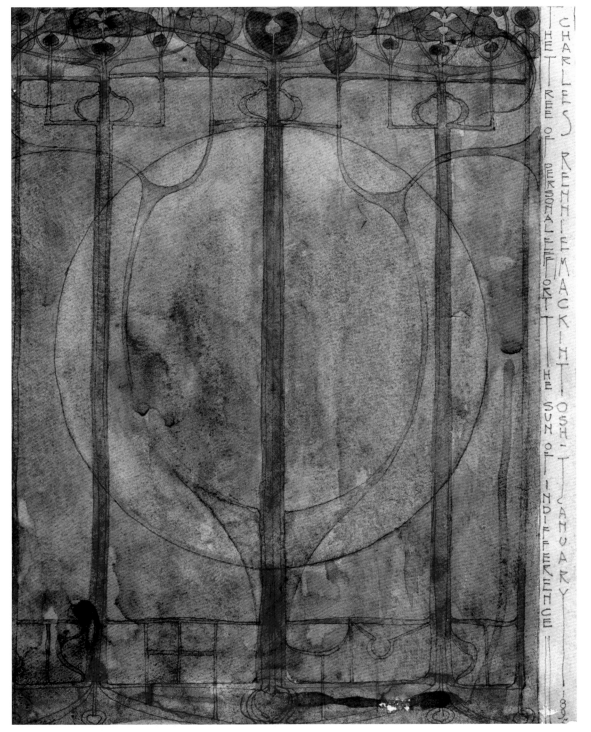

Charles Rennie Mackintosh (1868–1928)
Watercolour on paper • Glasgow School of Art, Glasgow

The Tree of Personal Effort, 1895. This is one of three watercolour studies by Mackintosh related to his intense period of study at the Glasgow School of Art that ended in 1892, showing how he embraced John Ruskin's maxim: 'look to nature'.

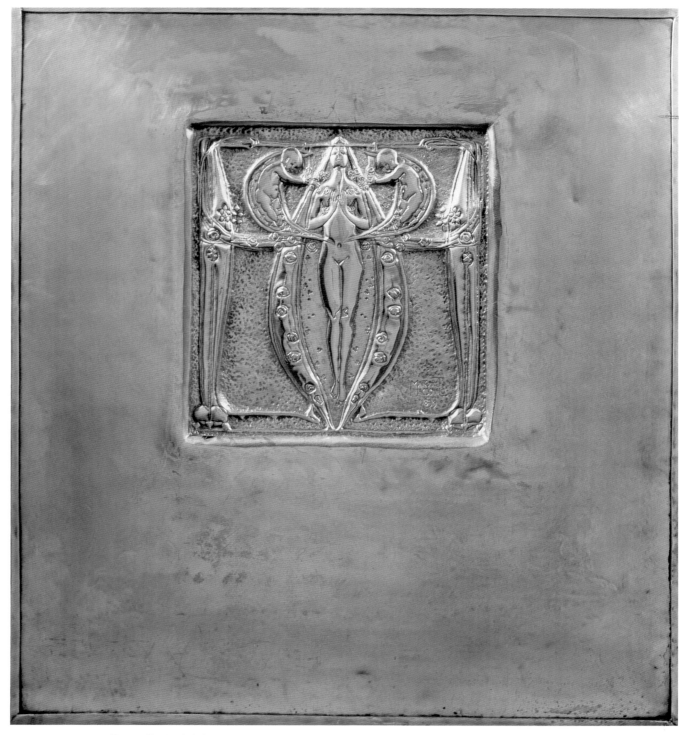

Margaret Macdonald (1865–1933) **Decorative panel, 1898–99.** This panel was exhibited at the Vienna Secession exhibition as part of a
Beaten brass • The Hunterian Museum and Art Gallery, Glasgow fire screen. It depicts a woman in a state of joy flanked by two children and is closely related to works
by Gustav Klimt.

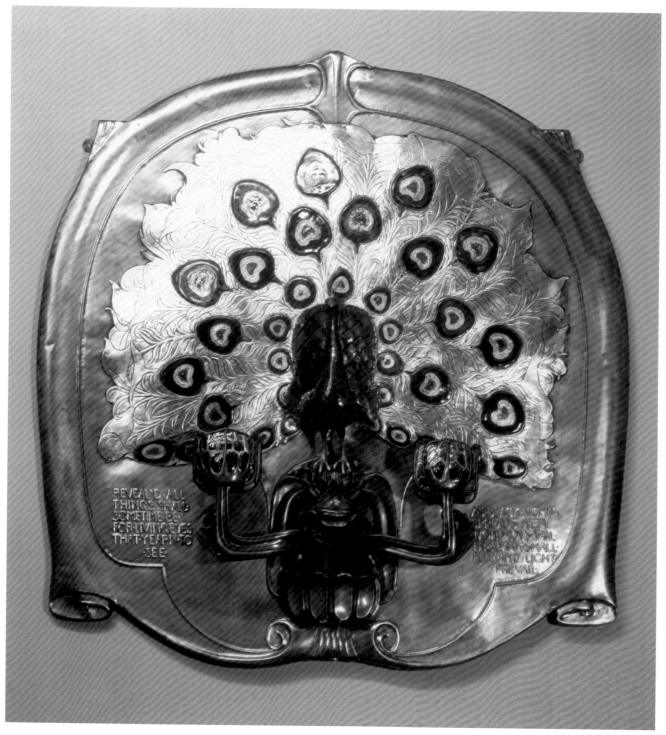

Alexander Fisher (1864–1936)
Enamelled metal • Victoria and Albert Museum, London

The Peacock Sconce, *c.* 1899. Having trained in the art of enamelling in Paris, and already a trained silversmith, Fisher combined these talents to make an extraordinary group of fine pieces for the more discerning and wealthy client.

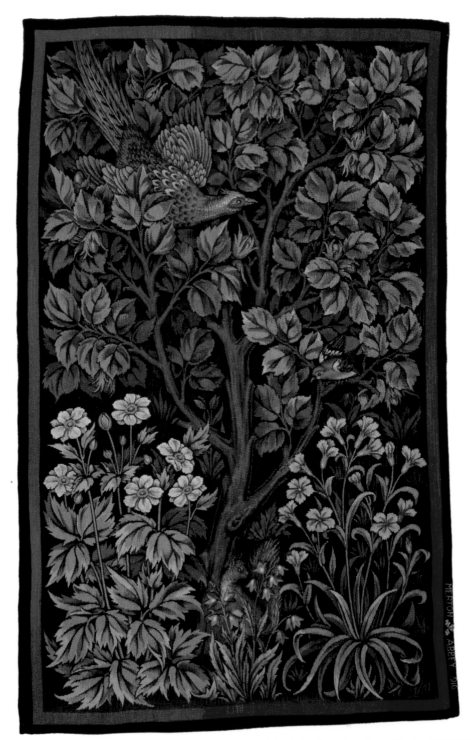

John Henry Dearle (1860–1932)
Wool • Birmingham Museum and Art Gallery, Birmingham

Cock Pheasant Tapestry, late nineteenth century. Many of the tapestries by Dearle are virtually indistinguishable from those designed by Morris, and also those by Burne-Jones prior to Morris's death in 1896, as Burne-Jones and Dearle often worked in collaboration for Morris & Co.

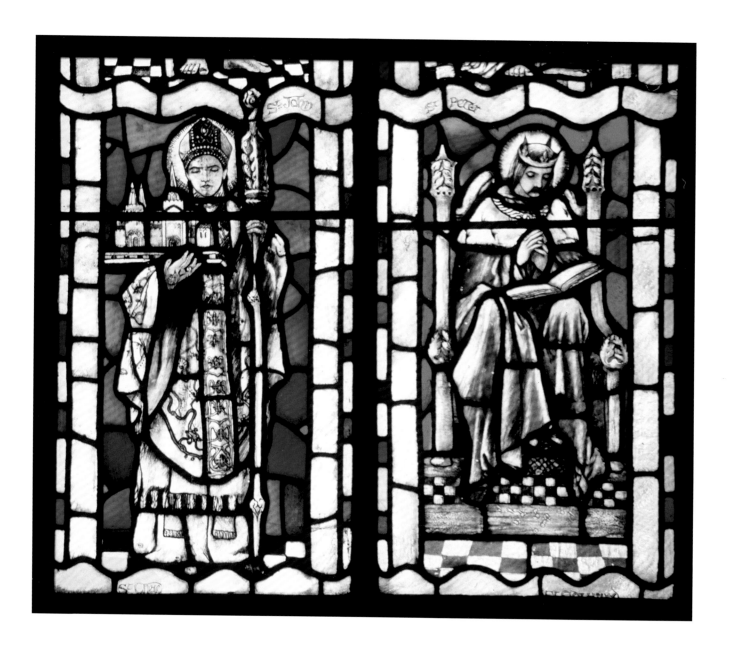

Christopher Whall (1849–1924)
Stained glass • All Saints Church, Brockhampton-by-Ross

St John and St Peter, *c.* **1900.** The architect William Lethaby built All Saints Church at the turn of the century. Naturally, he commissioned several Arts and Crafts practitioners to design some of the features, including this window by Whall.

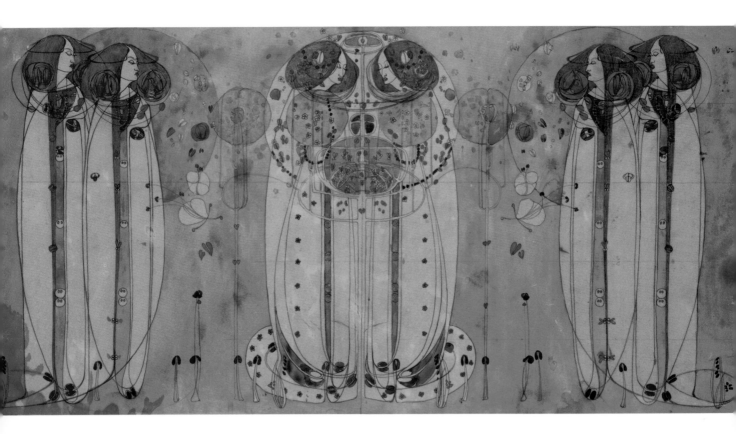

Charles Rennie Mackintosh (1868–1928)
Watercolour and pencil on paper • Private Collection

The Wassail, 1900. This design was intended as part of a decorative scheme for the interior of the Ingram Street Tea Rooms in Glasgow. Catherine Cranston, who owned it, also commissioned Mackintosh to design other interiors for her.

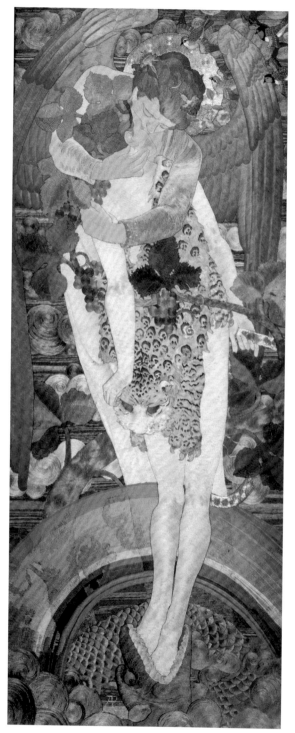

Phoebe Anna Traquair (1852–1936)
Silk and gold thread embroidery on linen
• Scottish National Gallery, Edinburgh

Progress of a Soul: The Victory, 1902. Traquair was a Scottish Arts and Crafts practitioner who was greatly influenced by the art of Dante Gabriel Rossetti, an influence notable in this embroidery. The work is one of four panels executed by her on the same theme.

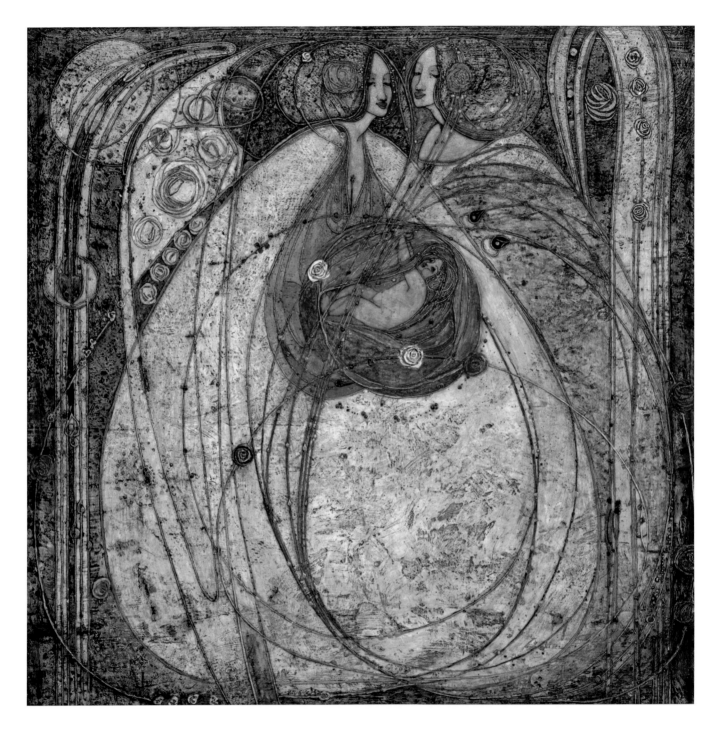

Margaret Macdonald Mackintosh (1865–1933)
Painted gesso over hessian • Private Collection

The Heart of the Rose, 1902. At 1 sq m, this was intended as a decorative wall hanging. The use of gesso as a ground would have given a porcelain-like surface to paint on, suggesting that the artist was creating a secular fresco.

Mackay Hugh Baillie Scott (1865–1945)

Lithographic plate • Calmann and King, London

Embroidered panels, 1903. Most of the Arts and Crafts practitioners were represented in *The Studio* magazine at some point. It was how designers and craftsmen disseminated ideas and trends to their contemporaries and to the public at large.

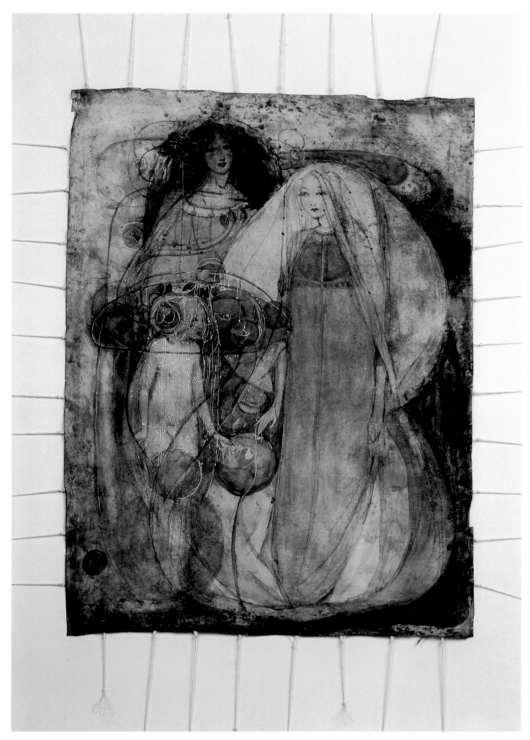

Frances Macdonald (1873–1921)
Watercolour on vellum • Dublin City Art Gallery, Dublin

The Birth of the Rose, *c.* 1905. In 1899 Frances Macdonald married Herbert McNair but was already collaborating with him, her sister Margaret and husband Charles Rennie Mackintosh on decorative schemes as 'The Glasgow Four'.

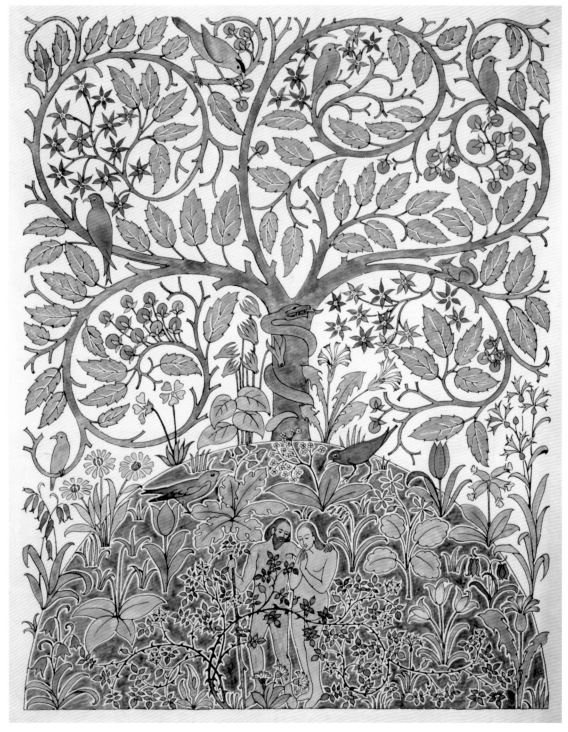

C.F.A. Voysey (1857–1941)
Watercolour on paper • Private Collection

Adam and Eve design, early twentieth century. The pattern surrounds the biblical narrative and incorporates all the elements of the story: the apple tree with the serpent wrapped around its trunk and, of course, the naked couple themselves.

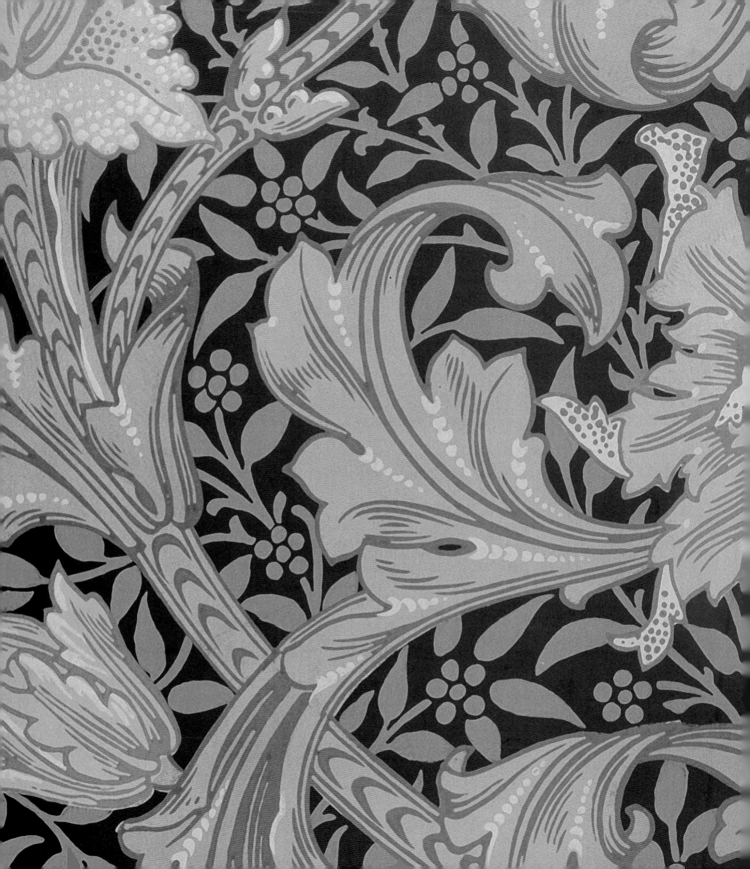

Wallpapers

One of the main catalysts for the birth of the Arts and Crafts Movement was the garish and vulgar wallpapers of the mid-nineteenth century that William Morris and others rebelled against, wanting to create a more pleasing aesthetic.

A.W.N. Pugin (1812–52)
Watercolour and pencil on paper • Victoria and Albert Museum, London

Wallpaper design for the House of Lords' library, *c.* **1840.** This design was one of several submitted for the decoration of the Palace of Westminster while it was being rebuilt after the devastating fire of 1834. Almost all the decorative detailing for the palace was by Pugin.

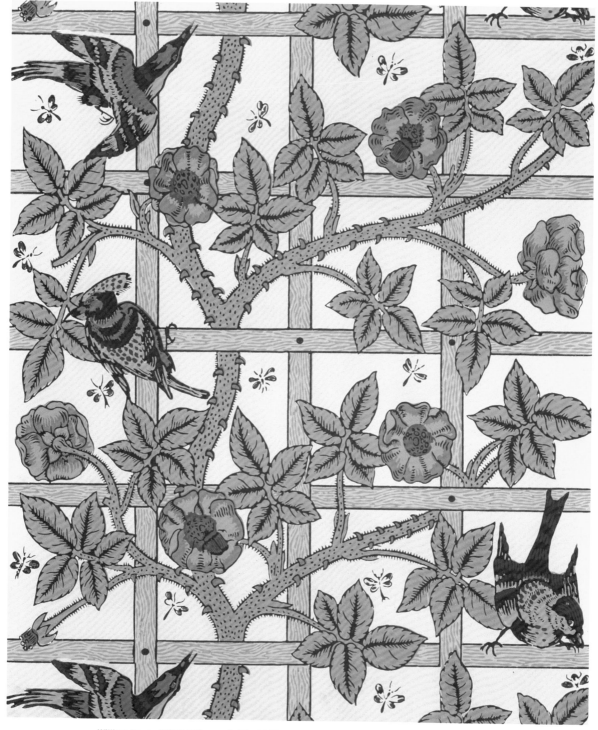

William Morris (1834–96)
Block printed wallpaper • Private Collection

Trellis, 1862. This design was one of the first created by William Morris. In the original design, the birds had to be drawn by Philip Webb who was more adept at drawing wildlife than Morris.

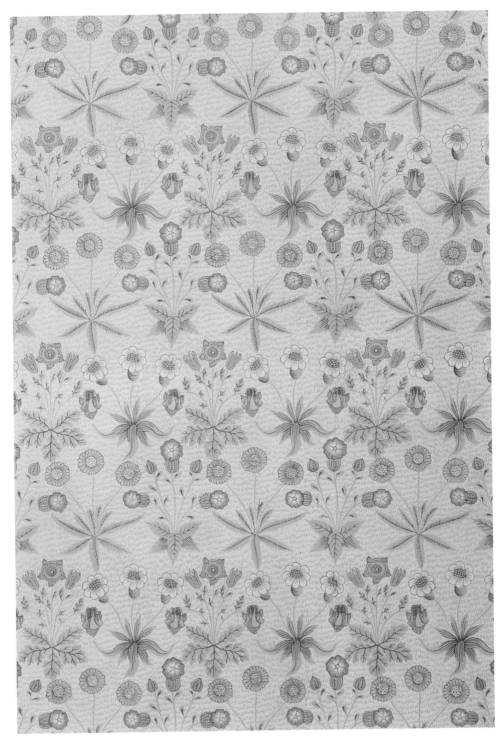

William Morris (1834–96)
Block printed wallpaper • Private Collection/Stapleton Collection

Daisy, 1864. Although *Daisy* was the first wallpaper actually designed by Morris, it was not printed until 1864. Like the first three of his designs, it was available to customers on a light (shown here), a medium or a dark background.

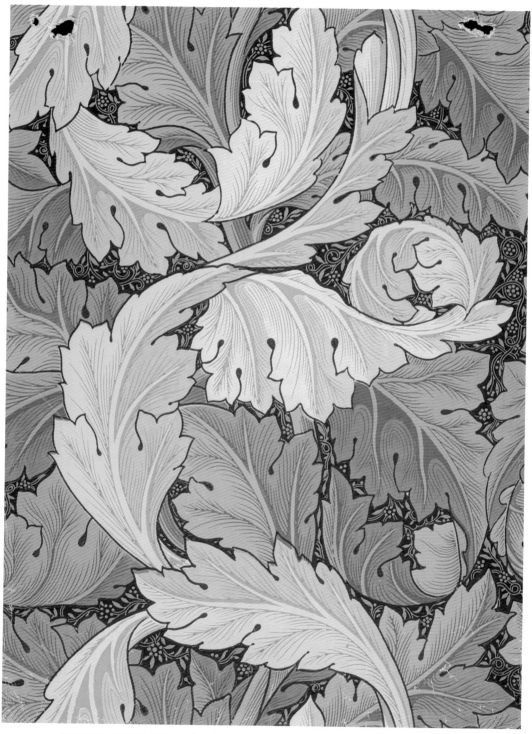

William Morris (1834–96)
Block printed wallpaper • Private Collection

Acanthus, 1874. Jeffrey & Co, the leading 'art wallpaper' firm of the time, printed this design. Before executing Morris's wallpapers they were already printing designs by Owen Jones, which share the same subtle blend of colours.

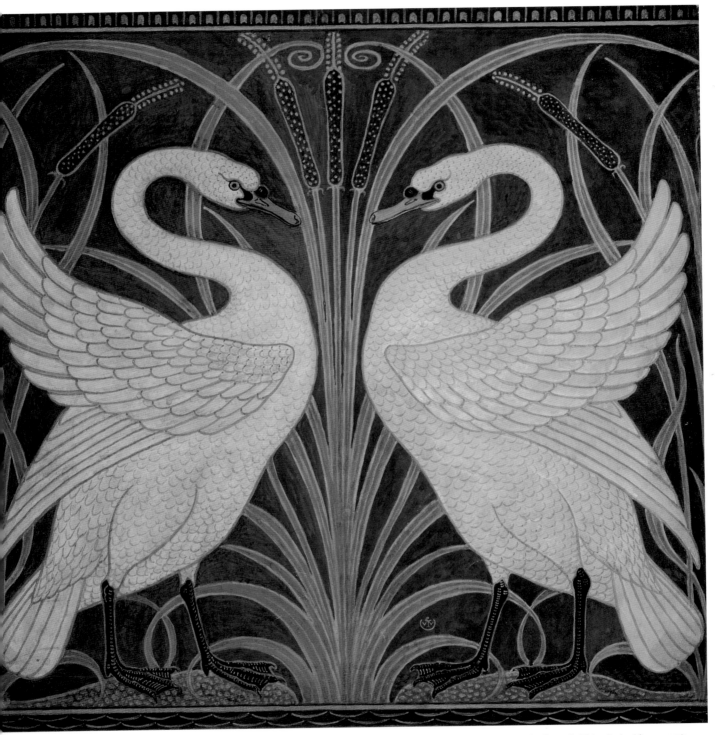

Walter Crane (1845–1915)
Bodycolour on paper • Victoria and Albert Museum, London

Swan, Rush and Iris, 1875. A very lyrical and witty design by Crane that takes its lead from aspects of the Aesthetic Movement but is also indebted to his children's book illustrations. The curvilinear lines anticipate the Art Nouveau movement by 20 years.

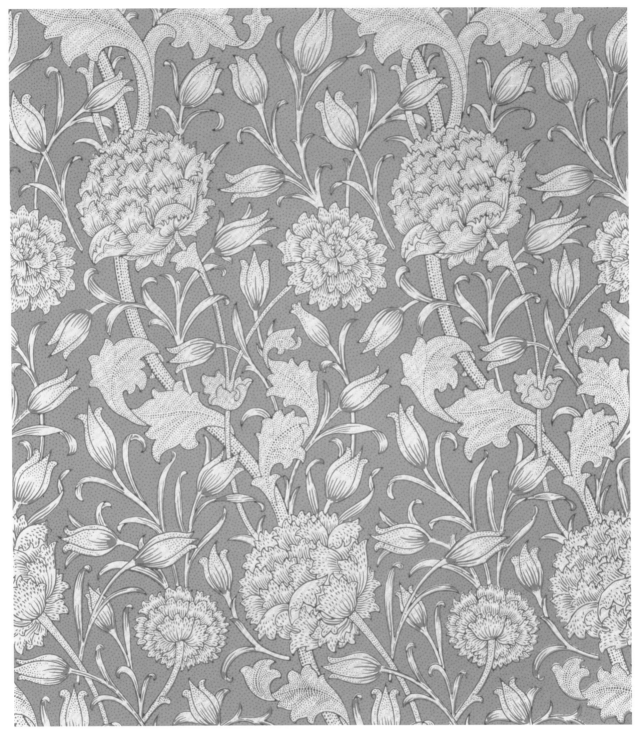

William Morris (1834–96)
Block printed wallpaper • Private Collection

Wild Tulip, 1875. This is the first of Morris's designs to incorporate the meandering diagonal, a feature that he repeated several times. It took up to 18 different blocks to print the design.

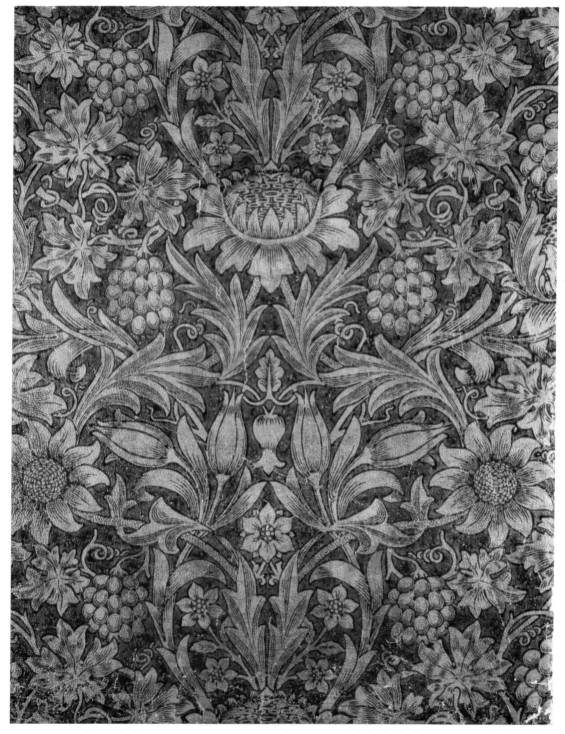

William Morris (1834–96)
Block printed wallpaper • Private Collection

Gold and Red Sunflower, 1879. The first of the *Sunflower* range was designed and printed in 1877. The example shown here was developed in 1879 and was very expensive, costing £1.50 per roll (approximately £130 today).

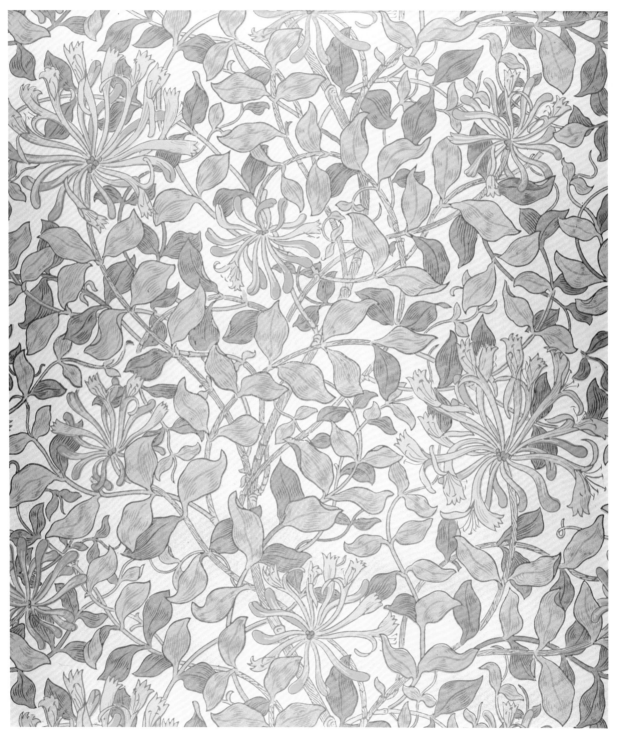

May Morris (1862–1938)
Block printed wallpaper • Private Collection

Honeysuckle, 1883. May Morris was born in the same year that her father designed his first wallpaper. This design follows the simplicity and reference to nature endorsed by William Morris and other early Arts and Crafts practitioners.

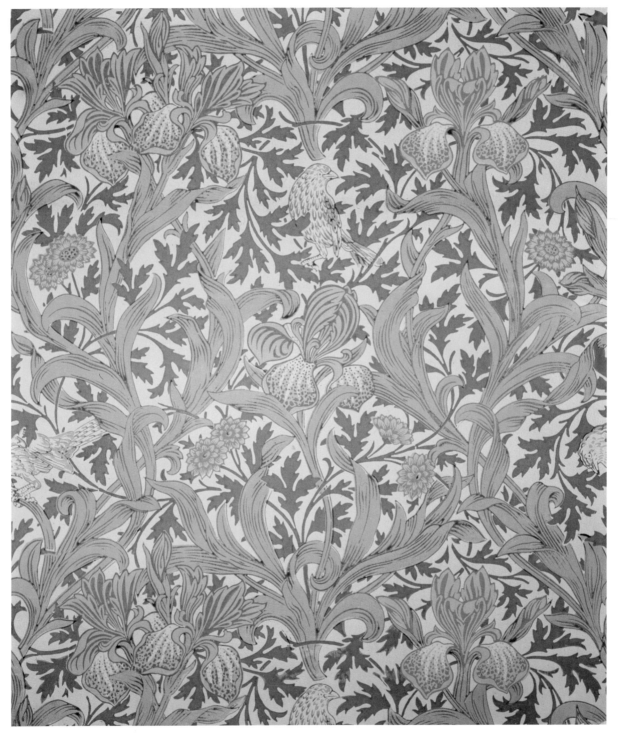

John Henry Dearle (1860–1932)
Block printed wallpaper • Private Collection

Iris, 1887. The first version of this design was created as early as 1877, using simpler and subtler colours. The pattern shown here was developed some 10 years later with more vibrant colours.

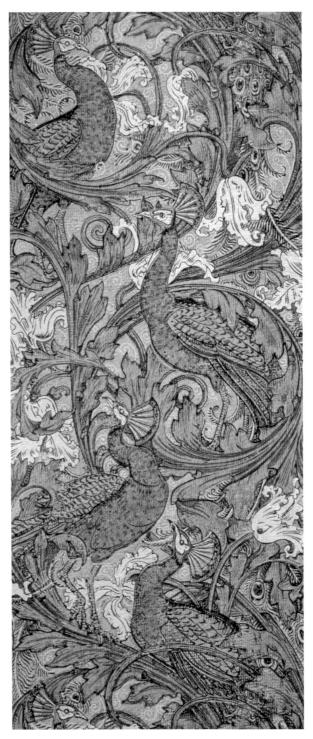

Walter Crane (1845–1915)
Block printed wallpaper • Victoria and Albert Museum, London

Peacock Garden, 1889. Crane clearly anticipates the development of Art Nouveau in this design with its colourful, sinuous motif. However, Crane himself referred to the style as a 'strange decorative disease'.

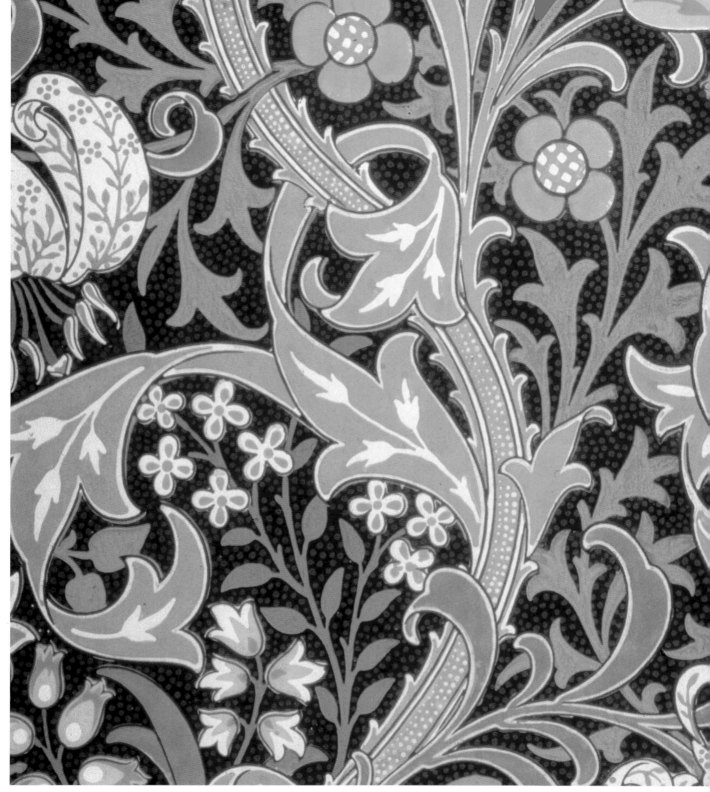

John Henry Dearle (1860–1932)
Block printed wallpaper • Private Collection

Golden Lily, 1897. Designed for Morris & Co, Dearle took the very popular meandering stem motif used by Morris. This was the first design by him to appear after William Morris's death.

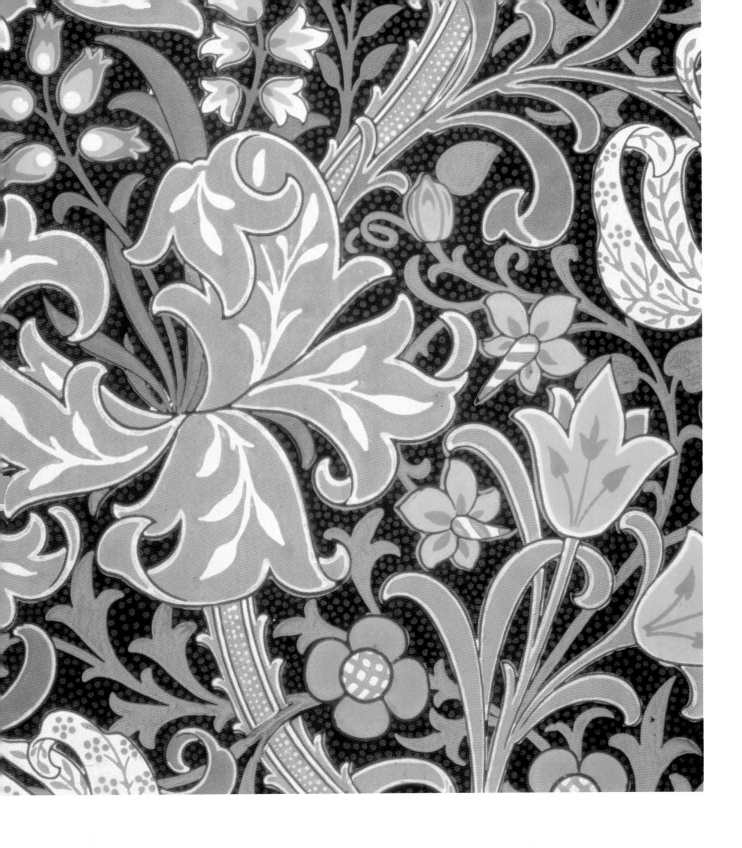

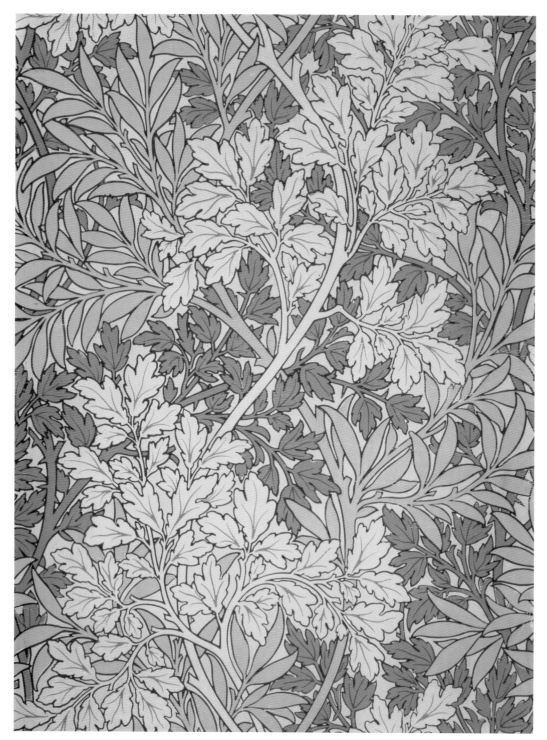

John Henry Dearle (1860–1932) **Foliage, 1899.** This image shows Dearle moving away from the influence of William Morris
Block printed wallpaper • Private Collection with the confidence to develop his own style, which is much simpler and less intricate in colour.

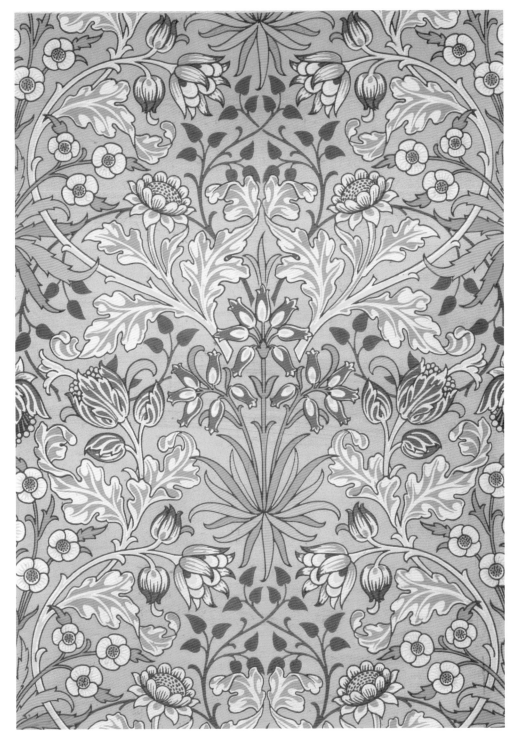

John Henry Dearle (1860–1932)
Block printed wallpaper • Private Collection

Hyacinth, *c.* 1900. Dearle's design demonstrates how far his own work had evolved from that of Morris in this very stylized and unnatural depiction of the hyacinth plant, which has much more to do with the flat pattern influence of Owen Jones.

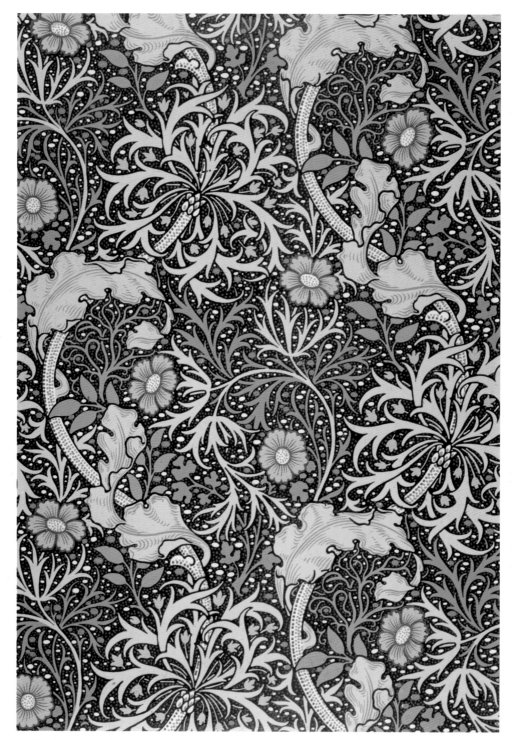

John Henry Dearle (1860–1932) **Seaweed, 1901.** The *Seaweed* design takes Dearle further along the development of his own style, which
Block printed wallpaper • Private Collection/The Stapleton Collection clearly has the influence of other sources. In this case it is Art Nouveau, with its sinuous entwined lines.

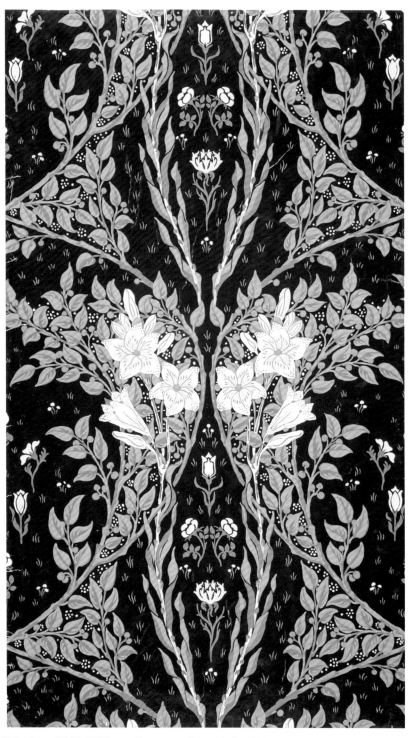

Walter Crane (1845–1915)
Block printed wallpaper • Private Collection/The Stapleton Collection

Francesca wallpaper design, 1902. The name Francesca means 'free', a suitable title for this design that appears to be unrestricted by the borders of the wallpaper. The pattern repeat is large enough to accommodate the continuous lines on to an adjoining roll.

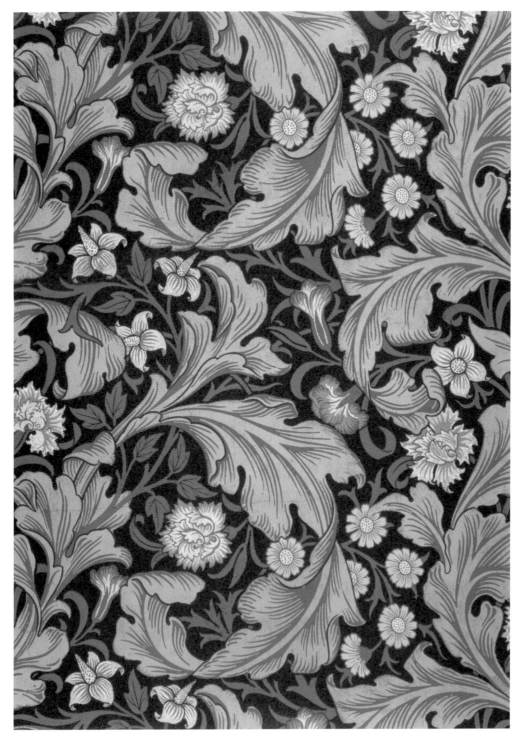

John Henry Dearle (1860–1932)
Block printed wallpaper • Private Collection

Leicester wallpaper, 1911. The sinuous lines of the acanthus leaves are borrowed from Morris's design of 1874, but the addition of the small daisies and carnations is very much a Dearle feature in this work for Morris & Co.

Kathleen Kersey (b. 1889, fl. 1913) for Morris & Co
Block printed wallpaper • Private Collection

Arbutus, 1913. Kathleen Kersey came to work for Morris & Co at the beginning of the twentieth century. This design borrows the simplicity of Morris's *Willow Bough* as a background, and then adds the very distinctive red of the strawberries.

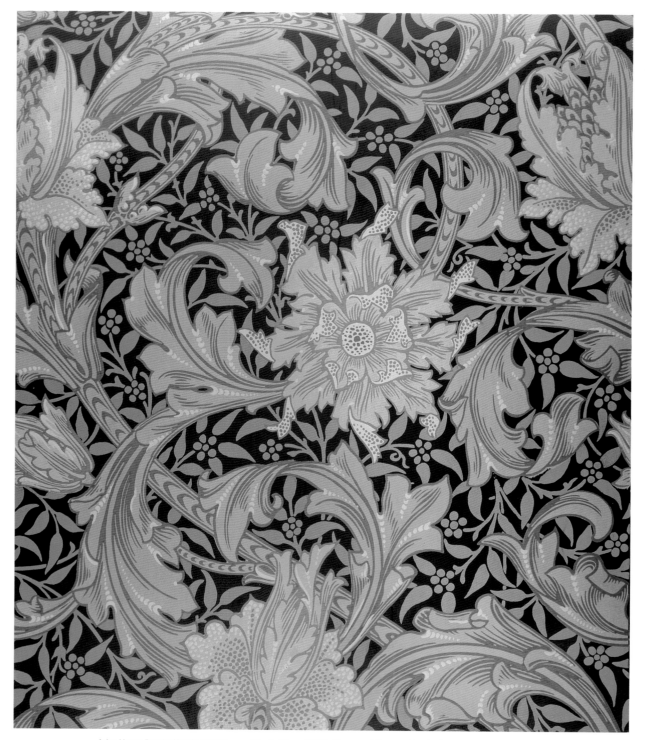

John Henry Dearle (1860–1932)
Block printed wallpaper • Private Collection/The Stapleton Collection

Single Stem, 1905. The use of the acanthus leaf as a decorative motif dates back to the ancient Greek world when it was used to decorate the capitals of Corinthian columns. It was also subsequently used in Byzantine architecture.

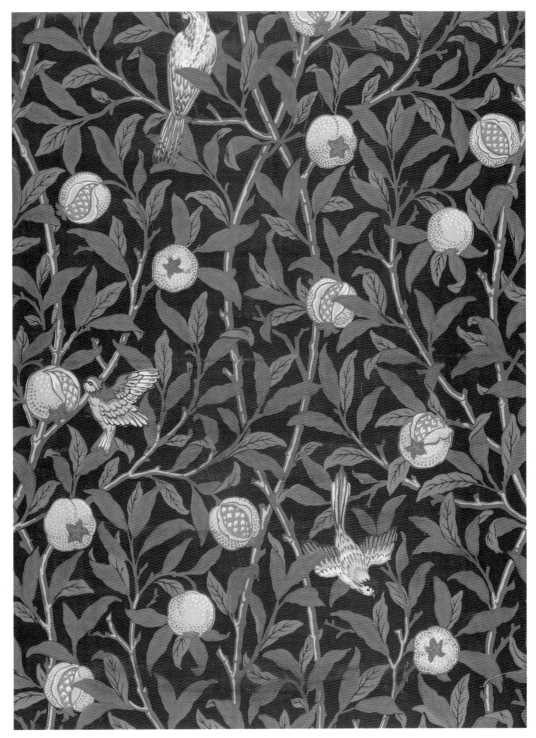

John Henry Dearle (1860–1932)
Block printed wallpaper • Private Collection/The Stapleton Collection

Bird and Pomegranate, 1926. Dearle takes the starting point for this design from William Morris's own *Pomegranate* wallpaper, but adds the birds himself, something that Morris was unable to, since he could not draw wildlife to a high enough standard (*see Trellis*, 1862, on page 107).

Indexes

Index of Works

Page numbers in *italics*
refer to illustrations.